FABRICS
and Wallpaper
TWENTIETH-CENTURY DESIGN

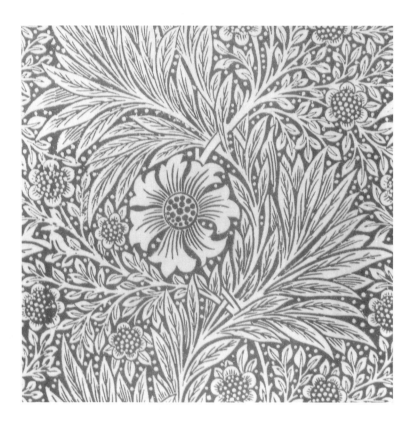

Mary Schoeser
E.P. DUTTON New York

To my mother

First published, 1986, in the United States
by E.P. Dutton

© **Mary Schoeser, 1986**

Published in the United States by E.P.
Dutton, a division of New American
Library, 2 Park Avenue, New York, N.Y.
10016.

Library of Congress Catalog Card Number:
86-71625

ISBN: 0-525-24462-X (Cloth)
ISBN: 0-525-48260-1 (DP)

OBE

10 9 8 7 6 5 4 3 2 1
First Edition

Designed by Richard Crawford
Typeset by TJB Photosetting Ltd, South
Witham, Lincolnshire, England.
Produced in Great Britain

Other books in the series:
FURNITURE
CERAMICS
GLASS

Forthcoming titles:
ELECTRICAL APPLIANCES
OFFICE FURNITURE

*Overleaf: Marigold, designed by William Morris as a wallpaper in 1875, but
concurrently produced on a variety of fabrics. Marigold fabric is still sold by
Liberty's of London, although altered to suit modern production methods.*

CONTENTS

PREFACE

IF on any one day in 1935 all the samples from one London textile showroom had been laid side-by-side, they would have covered three football fields. Such computations do little to increase our understanding of the development and use of wallpapers and furnishing textiles – the subject of this book – but they do provide some indication of the scale of the task at hand.

Because so many furnishings have been produced in this century, my focus has been narrowed to two areas: mass-produced goods, with discussions of the hand-made furnishings which influenced them; and within this, English and American manufacture. Of course, to do this, one must also consider European and (more recently) near and far Eastern products, since they have had considerable impact on the changing fashions in furnishings and their own fortunes have been closely intertwined with those of the English speaking world.

While many fabrics and wallpapers were produced, little has sur-

Part of the Swedish entry in the New York World's Fair, 1939, showing the type of textiles – simple weaves and bold prints – which they continued to export to North America well into the 1950s. The fabric on the left is 'Wheat Ear' by Astrid Sampe, printed by Boras Wäfveri for NK on rayon.

vived, particularly from the first half of the century. Furnishings (the term I have chosen to indicate domestic textiles and wallpapers together) are the most ephemeral elements of an interior, designed to be used and then discarded. Much of the evidence must therefore be drawn from contemporary journals and books, as well as more recent historical studies. Thus reference to these sources is made often in the following pages. Without the aid of footnotes I have resorted to the sometimes cumbersome inclusion of the relevant book or magazine title within the text. The books are listed fully in the bibliography, but the journals are not, since virtually every 20th-century publication dealing with interiors, decorative arts or the furnishing trade will provide information. Much useful information comes, of course, from the textiles and wallpapers themselves, and any student of their history should grasp every opportunity to examine samples first-hand.

INTRODUCTION

"....fabrics speak a mute language, like flowers, like skies, like setting suns";

Baudelaire

IT is widely accepted that 20th-century design philosophy arose out of Germany. There, at the Deutsche Werkbund (founded in 1907) and its successor, the Bauhaus, the machine ethic of 'form follows function' was established. The avant-garde since then have often evoked this formula and indeed it can readily be applied to many consumer products of the last 65 years, particularly those which employ new technology or materials. Textiles and wallpapers, by contrast, are not new to the 20th century. The mechanization of textile production was central to the industrialization of 18th and 19th-century western culture. Their use and significance too is rooted in a much older tradition in which textiles offered a principle source of insulation, warmth, privacy and prestige. All but the latter could be obtained equally well through the use of unpatterned textiles, just as badly plastered walls could be covered by plain (and unpainted) paper.

For centuries, however, the decorative and symbolic content of textiles and wallpapers have been of paramount importance. In the western world this has remained true partly because textiles, wallpapers and paint are the least expensive elements of an interior and can thus most readily act as indicators of taste and individuality. To this must be added the fact that until the middle of the century a fairly frequent change of wallpaper and textile furnishings was advised on the grounds of cleanliness, to combat the grime of gas lighting and coal fires.

These factors have made changes in style (over time) and variety of design (at any one time) essential. Such ephemeral aspects are difficult to square with modernist theories of design aesthetics, which in the strictest sense can only be satisfied by those functional woven textiles evolved over the last 60 years for heavy use in which appearance is limited by, and relates directly to, the required physical properties and construction. The problems associated with this fact were recognized early on by H.G. Hayes Marshall who in 1939 introduced his study of *British Textile Designers Today* with the admission that he was: *"never quite sure if Textile Designs should be included in Industrial Design or not — obviously an artist who designs textiles is applying his art to an industrial purpose, but somehow it seems altogether different from designing motor car bodies and aeroplanes which are products of new conditions...."*

Britian's Society of Industrial Artists and Designers (SIAD) had equal difficulty with its arrangement of illustrations in *Designers in Britain 3*, which appeared in 1951, the year of the Festival of Britain and the 21st Anniversary of the founding of The Society of Industrial Artists (as it was then called). They had gone little further towards solving the dilemma pointed out by Hayes-Marshall 12 years earlier: under 'Industrial Design-Form' fell all mass-produced products except textiles; these were to be found at the back of the book under 'Industrial Design-Pattern'. The implication is that pattern is *not* a function of textiles. However, all the evidence is to the contrary. While we would probably wish not to rely on a 'witty' washing machine or an 'amusing' airplane, these adjectives are regularly applied to textile and wallpaper design as a means of signifying approval.

It is no coincidence that the

words chosen to compliment furnishings are often used to the same purpose towards people. The role of wallpaper, upholstery and curtains has always been to personalize or humanize the space in which they are employed, irrespective of any other function they may perform.

To find an aesthetic which embraces the value of pattern one must turn to the 19th-century Arts and Crafts movement, of whom the most noted participant was William Morris. This movement was, by 1900, an amalgamation of over 50 years of artistic activity, including amongs its contributors architects, writers, philosophers, craftsmen and designers. Their work and ideals are well documented and any student of 20th-century design should become familiar with them. Here it must suffice to single out Morris's advice to the Commission for Technical Instruction in 1882: "*On the whole one must suppose that beauty is a marketable quality and that the better the work is all round both as a work of art and in its technique, the more likely it is to find favour with the public.*"

Although many of his hand-made products were too expensive to allow them widespread use in his own lifetime, Morris's wallpapers and printed fabrics (being the least expensive) were a decisive factor in the spreading of his influence. In par-

'Lion' frieze and 'Rose Bush' wallpaper, designed by Walter Crane and produced by Jeffrey & Co. in c.1900.

ticular, many of the first English proponents of what later became known as Art Nouveau were influenced by his theories of pattern-making. By the middle of the 1930s a self-conscious, decorated, hand-made (and often poorly made) piece would be condemned as 'artsy-craftsy'. But there is little doubt that the work of Morris and other Arts and Crafts designers made a significant contribution to the development of the designer's role in the wallpaper and textile industry. Some such as Walter Crane and C.F.A. Voysey are today

well-known; others such as Lewis F. Day and Arthur Silver are not. But they, together with other Arts and Crafts designers, bequeathed to the 20th century many basic principles, the most significant of which is the way in which they lobbied for good design.

Walter Crane was a founder member of the English Art Workers' Guild and served as Principal of the Royal College of Art (RCA) in the last years of the 19th century and, like many Arts and Crafts practitioners believed that through the education of designers (as opposed to technicians) better designs would be produced and society as a whole would be better served. Although Crane's two years at the RCA were unhappy ones, he was the first to attempt to bring the 'Renaissance man' concept of study to that college. Further, Crane himself designed wallpapers and textiles as well as carpets, furniture, ceramics and book illustrations; he painted and wrote on art and was thus qualified for this title himself. The ideal of a well-rounded designer is one that C. R. Lethaby (Crane's successor at the RCA) encouraged throughout his teaching career, which lasted until World War I and was one that inspired the method of teaching at the Bauhaus. Day, another founder member of the Art Workers' Guild, was among other designers in the first decade of the

20th century who typified the Arts and Crafts ideal. His designs for textile and wallpaper have often been overlooked – ranging as they do from Jacobean revival to simplified Art Nouveau motifs. However, through numerous books, articles and lectures, his attitude towards design had a wide influence. Thus, to lobbying through teaching can be added the Arts and Crafts expectation that designers should be articulate and well able not only to design, but to analyze and promote the rationale behind their work – expectations still held today.

The importance of designers such as Crane and Day is that they not only lobbied for good design – they produced it. Such work was often advanced in stylistic terms (or avant-garde) but it was also commercially successful. Both designed wallpapers for Jeffrey & Co., and although many were the expensive hand-block prints, (and Crane's work for Jeffrey's also included designs for embossed leather), there were designs for the less costly machine-printed papers too, particularly by Day.

Their designs for textiles showed the same range. Crane produced designs for machine-printed cottons for Edmund Potter & Co., Manchester, hand-prints for Wardle & Co., and weaves for A.H. Lee. From his position as Art Director of Turnbull & Stockdale, textile printers, from its foundation in 1881 until his death in 1910, Day was particularly well placed to design for his customers. Day's designs for Turnbull & Stockdale were principally for mass-production, but hand-printed velveteens were also produced, both by this firm and by Wardle's.

Together Crane and Day's work indicates the advanced stage of mass-production Britain's furnishings manufacturers had reached – employing designers whose variety, inventiveness and creative ability made English products so widely appreciated at the end of the 19th century.

Throughout this century the battle for supremacy in the public eye used two vehicles established as effective by the Arts and Crafts movement: journals and exhibitions. In Germany, the name of the turn-of-the-century style was 'Jugendstil', derived from *Die Jugend*, published in Munich from 1896. A year before *Die Jugend* began, *Pan* was being published in Berlin; Vienna had *Kunst und Kunsthandwerk* from 1898 to 1921; from Paris came *Art et Decoration*, started in 1897, and there were many others. But the most influential was *The Studio* published in London from 1893 and, from 1906, joined by *The Studio Year-book*.

From this period art journals proliferated, supported by the enlarged, wealthier middle class for whom an interest in 'artistic' matters – including interiors – was becoming an important expression of their social position. As printing methods became cheaper and increased revenue became available from advertising (gradually recognized as another powerful form of style lobbying) such art journals were joined by trade journals, home and fashion magazines and the in-house publications of recent years: Habitat, Laura Ashley and so on. The gradual addition of colour printing helped to steadily enlarge the circulation and variety of journals which catered to the growing consumer society and this in turn has influenced the appearance of wallpaper and textiles and the fortunes of their manufacturers. Even in the late 1890s *The Studio* was widely circulated in Europe, contributing significantly to the dissemination of Arts and Crafts principles, many of which were put forward by the designers themselves. The late 19th and 20th century journals are thus an excellent chronicle of the decorative arts and in their own time served as a vehicle towards an international style as well as a style guide to the manufacturers of less expensive textiles and wallpapers.

Exhibitions served the same purpose, although the records they leave behind are often more difficult to

Part of the Marion Dorn Ltd display as arranged by Hans Schleger at the influential 1933 Dorland Hall exhibition in London.

locate and interpret. The International Exhibitions which occurred between 1900 and 1940 were generally viewed by manufacturers as trade fairs through which they could increase exports to the host country, and by the sponsoring country as promotions to increase their own. Museum and gallery-organized exhibitions fed the decorative arts with fresh ideas, while exhibitions organized by individuals or groups showed the results. From the late 19th century the latter were often organized by associations set up specifically for this purpose, of which England's Arts and Crafts Exhibition Society, founded in 1888 and influential for nearly 20 years is a prime example.

In more recent years the shop window and Government and state financed organizations have largely replaced this type of exhibition, but in the first 40 years of the century

they were an important route by which designers could reach – and influence – the public.

Whether formed and financed by governments, industry, individual designers or any combination of the three, the design organizations, journals, workshops and art colleges which lobbied for better design in Europe and America during the first half of this century counted the Arts and Crafts movement in their lineage. But even in England the movement spauned many proponents, each slightly different in intention. Thus its influence on individual designers, manufacturers and promoters led to methods and results which differed enormously.

Such diversity can be found within a single designer's work, of which C.F.A. Voysey is a useful example. An Arts and Crafts architect whose reputation today rests on his revival of the English vernacular style, he was also a prolific pattern maker who evolved designs with personal symbolic content. However, his almost indiscriminate sale of designs to manufacturers across Europe meant that he had no involvement in their eventual production – in direct conflict with the principles associated with the Arts and Crafts movement. Further, Voysey symbols particularly his stylized birds – were read simply as Voysey style and rapidly became a part of furnishings'

design language, as in fact, did the patterns of William Morris.

Many of the Arts and Crafts principles have, of course, been disputed by the style-lobbyists who influenced 20th-century design. Nevertheless, in doing so they relied on the interdisciplinarian characteristics proven by the Arts and Crafts men and women as effective means of influencing design: they wrote, lectured and practiced, joining together to promote, discuss and stimulate their work and their profession.

For an example of a true interdisciplinarian, one need look no further than William Morris, who is also important for a further reason – he sold his work directly to the public. Together with a group of friends he established Morris, Marshall, Faulkner & Co. in 1861, to be re-organized under his leadership as Morris & Co. 14 years later. Although he died in 1896, the firm continued to trade until 1940, despite a decline in business from c.1925, when the firm's name changed to Morris & Co. Art Workers Ltd. During Morris's lifetime, the designer-owned shop was rare, and they remained so until the 1910s. The large wholesaler/manufacturer had amassed fortunes in the 19th century by virtue of their hold on design choice and were loath to disperse their influence and wealth by co-operating with small designer-led firms. That they were nevertheless

gradually forced to respond to the wishes of design leadership from outside their ranks is one of the most significant aspects of furnishings in this century.

Morris was able to open his shop because he had two basic prerequisites: money and, eventually, the ability to make his own goods. The success and longevity of this enterprise set an important precedent for the 20th century, reflected in the parallel move against the wholesaler's stranglehold which came from another quarter in the last years of the 19th century and the first decades of the 20th. With improved public transport and greater wealth among the middle classes, who were also more confident in their choice of goods (secured, no doubt, by their perusal of the lastest art journal) came a consumer who was attracted to the major cities and, once there, to the large shops (or what we would call department stores). As a result some, such as L'Art Nouveau, opened by Samuel S. Bing in Paris in 1895, commissioned work directly and often also had their own workshops.

Although Bing's shop gave its name to the English speaking world for the energetic, whiplash-like semi-naturalistic floral motifs which dominated wallpaper and textile design at the turn of the century, the Italians preferred the name 'Stile Liberty' and the French, 'Le Style Libertie'. These

epitaphs acknowledge the influence of Lazenby Liberty, who opened his main shop in London in 1875 and another in Paris in 1889.

Although initially an importer of 'artistic' goods from the Far and Middle East, Liberty was one of the first shop owners to work directly with designers, commissioning new fabrics with such success that the firm was able to establish its own print works at Merton Abbey, near to those of William Morris. Although known to the public as Liberty textiles, the Art Nouveau patterns which carried his name were the work of designers such as Arthur Wilcock, Lindsay Butterfield, Harry Napper, John Illingsworth Kay and Arthur Silver. The latter three were of the Silver Studio, founded in London in 1880 and active until 1963.

Shops such as Liberty's, L'Art Nouveau and, also in Paris, La Maison Moderne (specializing in less expensive goods) were among the first to direct public tastes and influence manufacturers. This is reflected in the fortunes of the Silver Studio which passed from the direction of Arthur Silver to his son Rex in 1893 and which, during the peak years of the fashion for Art Nouveau, sold designs to at least 8 of the major French textile manufacturers. Mark Turner suggests in the catalogue of the Silver Studio collection at Middlesex Polytechnic that these

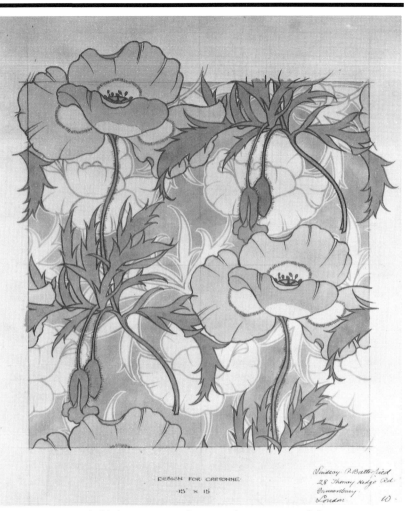

DESIGN FOR CRETONNE
15" × 15"

Lindsay P. Butterfield
28 Thorney Hedge Rd.
Gunnersbury
London W.

A Lindsay Butterfield design, 'Iveagh', one of many turn-of-the-century fabrics known to the public by its manufacturer, Liberty. It was produced in both printed and woven form.

manufacturers were most likely to have been directed to the studio by English customers such as Liberty. In the early 20th century the American stores Macy and Marshall Field also bought from the studio, possibly for the same reason. While the designer/retailer or design-led retail firm was

an exception at the beginning of the century, their impact on the publics' opinions and buying habits increased as the century progressed placing 'the shop' among the style-disseminators or lobbyists.

Very little is known about the many studios, such as Silver's, at work throughout Europe and America in this century, despite efforts to bring the designer to the fore. Even during the 'designer-name' era which was strongest from the mid-30s to the mid-60s, the majority of furnishing textiles and wallpapers have been marketed under the name of the major supplier – whether shop or manufacturer. This may be because it is easier to remember one name than 50. Or, Morris's belief that textile and wallpaper design was *'a lesser art'* may have some validity – at least to the extent that architecture, interior design and furniture design have in this century exerted an influence on the design and selection of furnishings. Distasteful as it is to the furnishings designer, a glance at a selection of architecture, interior and furniture journals from the last 100 years will confirm that acknowledgement of the wallpaper or textile designer is omitted far more often than it is included. Even in Morris's own firm there was no attempt to distinguish for the customer between Morris's furnishings designs and those of

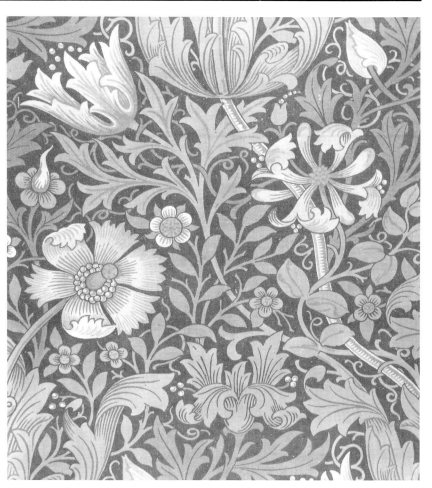

'Compton', designed by J.H. Dearle in 1896, but often ascribed to William Morris. Both 'Compton' wallpaper and textiles were printed at Merton Abbey from the same blocks.

Henry Dearle, who joined the firm in 1878 and was manager of the shop from 1896 to 1932. The result was that the work of both men came to be known as a 'Morris' pattern – a con-venience derived both from the name of the shop and Morris's fame as a poet, socialist, stained glass designer and fine-book publisher. Thus another trend which began with

Morris now dominates.

The Studio's comment of 1896 that *"Now a 'Voysey wallpaper' sounds almost as familiar as 'Morris chintz' or 'Liberty silk'"* demonstrates how very well Voysey had done for himself, for an updated list would be dominated by names such as Foxton's, Omega, Martine, Edinburgh Weavers, Knoll, Heal's, Larsen, Habitat, Memphis, and so on – names of firms which together encompasses the work of the five hundred or more designers.

During the late 19th century many of the means of promoting new, better or just different design – particularly the use of the new journals and exhibitions – occurred more or less simultaneously in Europe, America, and Britain. So too did the concept of architect–led design, by which a complete, integrated interior was considered essential. In the development of 20th century wallpaper and textile manufacture and the role of their designers, the Arts and Crafts Movement nevertheless serves as the most significant model, for it combined, for the first time, *all* the major proven forms of style lobbying with a concern for pattern which enhanced the status of furnishings.

Morris's designs in particular demonstrate the continued potency of his principles of pattern making (well documented by Linda Parry in *William Morris Textiles*, 1983) for with the exception of the 1940s, there has been no decade since their initial production when some have not been available, even in a slightly altered form. Further, no country has been able to combine dominance in wallpaper and textile mass-production with leadership in their design since the UK achieved this in the late 19th century. But all have tried. In each country's efforts to bring their designers and manufacturers to the fore, shifts have occured in the relative importance of the various methods of disseminating and lobbying for new principles of design. But if the basic formula – first seen in full force in the late 19th cen-

An interior in Alaska, 1907. The wallpaper, although entirely in keeping with the American 'Arts and Crafts' style of the early 20th century, could easily have been designed 50 years earlier. Note also the sheer madras at the window.

tury — is the same pattern which influences us today, it is also as true today that 'style-lobbying' relies on the successful, determined or outspoken to express a point-of-view. The image handed down to us through evidence which remains must therefore be treated with some care.

While this is true in history generally, the study of the products under discussion has additional hazards: throughout the 20th century it has been possible (and not uncommon)

With incorporated friezes, 'crown' wallpaper designs such as 'The Apple Tree' by Sidney Hayward, were typical of turn-of-the-century invention.

to buy for example, a textile in New York sporting a design by a German studio which came from an English wholesale firm and was printed in France. If one returns to the Silver Studio records for the early 1900s, the main single buyer listed there is the Belgian textile manufacturer, Leborgne. And recently it was possible to visit the Design Council Shop in London (where the promotion of British design and manufacture is a Government financed mandate) and find textiles designed in America but made in England, together with others designed in England but made in Europe.

The disentanglement of these facts would be less difficult were it not to the advantage of the industry for much of this century to keep their suppliers, customers and designers confidential in order to protect themselves from 'pirating'. This may be why the prominent individual, workshop or retailer has received such attention throughout the century — we feel we know where we are with them. Consequently the in-house or studio designer is seldom, if ever, mentioned. The date at which a fabric or wallpaper was designed is also discreetly overlooked, unless it is of a respectable age or for use in the reconstruction of a period interior.

The conflict between modern and traditional design which characterizes most interior and exterior design of this century was often played out within individual firms as often as it was *between* firms, for new, experimental designs have often been supported by the commercial 'bread-and-butter' or conservative ranges, and have often been produced long after they could be regarded as modern.

To a manufacturer a 'good' design is one that sells for seven to ten years. Among the converters (England), fabricants (France) and jobbers (USA) — middle-men furnishings firms which liaise between mills, designers and customers (often furniture-makers, interior decorators and other wholesale firms) — the continuous production of one or two designs for 15-25 years is not uncommon. A collection of textiles in the Museum of Fine Art in Brussels — purchased in 1912 and 1913 from a fashionable Frankfurt shop, Walther — gives some indication of what all this means. The collection includes many late 19th-century, Morris-type designs; two cottons first printed by G.P. & J. Baker in 1899; both current and six to eight year old designs from the Weiner Werkstätte in Vienna; an early 20th-century design by the English architect/designer, M.H. Ballie-Scott; and a c.1911 design by Ortek of Berlin. And this is not an isolated example — in 1914 it was possible to buy a 19th-century Voysey-designed fabric from Liberty in Paris, together with textiles designed in 1912 and 1913. Did the eventual buyer care how new the design was or where it originated from? That so many similar examples could be found through the century suggests not.

Those who *did* care were the style lobbyists: the propaganda makers (i.e. journalists, exhibition organizers, lecturers and writers) and the progressive, articulate architects and designers, many of whom were themselves significant generators of propaganda. Together they sponsored changing fashions in interiors, bringing to their work a necessary dislike for whatever went before, even when it included their own work. That changes in furnishings occur simply for the sake of change has been true since the 18th-century development of the concept of interior design. *"As early as 1750 Mrs Montague was talking of being 'Sick of Grecian elegance and symetry, or Gothic grandeur and magnificence' and having to 'seek the barbarious gout of the Chinese'".*

To fully appreciate the forces at work on 20th-century furnishings one must study the parallel developments in 20th-century fashion, furniture, interior design and architecture, as well as 18th-century interior design — an antecedent to, and continuous influence on, both the use and appearance of 20th-century furnishings. The latter is well

'Chatsworth', a block printed cotton and linen cloth designed by C.F.A. Voysey in c.1897 and sold through Liberty's up to World War I. As an Essex & Co. wallpaper it was known as 'The Nure' and it was also produced as a lino by Alexander Morton & Co.

played. Instead the following chapters set out to chart the progress of good designs (which sell) and Good Design (which is approved by the style-lobbyists) – bearing in mind that in the responses to the tension created by attempts to satisfy the criteria for one or both can be found a reflection of the profound social, political and economic changes in our century.

Such tension shows itself in the switchback trail which leads between traditionalism and modernism, uniformity and ecclecticism, mass production and craft work, success and failure. These complex, overlapping tendencies operate within the limitations established by available technologies which are discussed in two separate chapters because their developments occur on a different time scale. The story of 20th-century furnishings is thus a syncopated score in which change, certainly, and progress, sometimes, form the countermelodies.

demonstrated by John Cornforth and John Fowler in *English Decoration in the 18th Century* (from which the previous quotation is drawn). These subjects are outside the scope of this survey, as is any attempt to recognize the many studio designers, technicians, engineers, salesmen, journalists, authors and exhibition organizers who have brought the few to prominence; it can only give an indication of the part that they

THE BATTLE FOR SURVIVAL
- INDUSTRIAL CHANGES: 1900 - 1939

IT is no exaggeration to say that for most 20th-century textile and wallpaper designers, manufacturers and retailers, survival has been an uphill battle. The century opened with England leading both in terms of design innovation and manufacturing strength. Despite this, the financial stability of England's wallpaper and textile firms was far from satisfactory. Following a general economic decline from 1890, which resulted in the closure of a number of long-standing firms, 1897 and 1898 were exceptionally bad trading years.

The industry's response was to form combines — amalgamations of similar firms, a concept now referred to as horizontal structuring. These occurred in almost every section of the industry: spinning, dyeing, bleaching, calico printing and wallpaper manufacture among them. The idea behind the combines was, of course, to monopolize trade, or at least control prices and reduce unnecessary competition. The real effect in many cases was to make such organizations more cumbersome and less able to deal with the effects of the radical social and political changes which occurred during the first four decades of the century. To see why, it is useful to look at the progress of two combines: the Calico Printers Association (CPA) and the Wallpaper Manufacturers Association (WPM), both founded in 1899.

The WPM was an amalgamation of the major mechanized wallpaper manufacturers, some of whom also did hand block printing. Of the constituent members, only Arthur Sanderson & Sons Ltd (founded 1860) effectively maintained its own identity to this day, by virtue of its independently owned showroom in Berner Street, London. The handful of small wallpaper manufacturing firms which remained outside the WPM did some machine printing but principally supplied hand-block printed papers which were approximately four times more expensive than the machine printed variety. For a further decade or two, an increase in imports and the production of these small firms offset the inevitable narrowing of choice brought about by the formation of the WPM, but in the intensely competitive market of the first three decades of the century many independent companies were forced to close. When they did it was Sanderson's or the WPM which bought their stock and patterns, most from the latter group going to Sanderson's in the end.

For example, in 1900 Sanderson's acquired William Woollams & Co., known since 1830 for their high quality hand-printed papers, especially their flocked designs (although they also produced designs in the last quarter of the 19th century by designers of note including G.C. Haité, Arthur Silver and C.F.A. Voysey). The demise of Woollams is partly attributed to the competition from new products such as 'leathers' and Anaglypta, in 1900 at least as expensive as hand-block printed papers.

Sanderson's products already

ranged across all price brackets and included 'skins' (imitation crocodile or similar finishes) and Japanese 'leather' papers (which they had imported since 1886). The latter remained popular until shortly after World War I, prompting Sanderson's to buy the entire stock of Rottman & Co.'s Japanese 'leathers' in 1914. They had already purchased Charles Knowles & Co. Limited of Chelsea in the previous year, acquiring patterns not only from Knowles' 61 years of production but in addition, from John Woollams & Co., acquired by Knowles in 1900. It is hardly surprising that Sanderson's was the only wallpaper company to exhibit at the Ideal Home Exhibition in London in 1910, nor that when the Essex & Co. showroom was sold in 1923 (the factory already being part of the WPM) it should go to the same firm. On the surface little changed for, perhaps because Essex & Co.'s reputation for good design was well established, their showroom was for some years afterwards run under the Essex name.

The fate of a further wallpaper firm indicates the risks involved in the production of limited-run, avant-garde patterns. In the catalogue of the 1985 Sanderson's retrospective exhibition, Christine Woods observed of Heffer, Scott & Co. that,

"in 1921 it was said that (the) firm

Wallpaper produced by Heffer, Scott & Co., c.1920. The fashion for Chinoiserie designs was particularly strong in the decade after World War I, as was the strong contrast between dark and bright colours.

had given ample evidence of its determination to succeed rather by the 'evolution and application of progressive ideas' than by the production of wallpaper in bulk and it may have been financial difficulties arising from this philosophy that enabled Sanderson to purchase a controlling interest in the firm in 1928".

She could equally well have been describing Essex & Co. or, for that

matter, Jeffrey & Co., which was taken over by the WPM in 1923. At the time of their closure, Jeffrey & Co. were still printing for Morris & Co. and this the WPM continued to do until 1940, when the Morris firm was voluntary liquidated. The manufacture from Jeffrey blocks had already been transferred to Sanderson's in 1927 and it was natural that the same occurred for the Morris blocks in 1940.

From 1900 the Morris & Co. patterns were no longer innovative, but Essex and Jeffrey together provided avant-garde designs up to c.1920, between them employing every prominent wallpaper designer of the period. Eventually the stranglehold of the WPM and Sanderson's was such that the likes of the Essex, Heffer and Jeffrey firms were no longer there to introduce new avant-garde designs.

By the late 1920s design innovation for English wallpapers was in the hands of the WPM. As the vogue for plain walls was becoming increasingly apparent, Sanderson's energies were directed towards their modern

printed textiles represented by the 'Eton Rural Cretonne' range, launched in 1921. Their wallpapers between the two wars were dominated by scenic designs and pale, textured, quasi-cubist patterns, often issued with borders and/or cut-out additions, as was the WPM's generally. It has often been noted that Britain was unique in maintaining its production and use of borders and friezes, which had gained popularity in the last quarter of the 19th century. The simple reason for this may well be found in the WPM's investment in the specialized machinery required, which, once installed, would be maintained in use for as long as possible.

It must be remembered that at the beginning of the 20th century the textile and wallpaper trade was dominated by the wholesalers, who manufactured or commissioned the merchandise they offered. Whether conservative or innovative, they dictated to a captive audience – mainly decorators, through whom their goods were sold. One of the effects of the Arts and Crafts movement and subsequent workshops, ateliers and werkbunds was gradually to eliminate the middleman.

Thus in France, which had few wallpaper firms at the turn of the century, artists and designers became directly involved in production, some setting up their own firms. In Ger-

Block printed and sprayed wallpaper borders manufactured by Sanderson's in 1935, shown here prior to cutting into separate strips.

One of the Sanderson's modern 'Eton Rural Cretonnes' of 1921–2, which received enthusiastic reviews in the trade press. This fabric range was the first to be printed at Sanderson's own Uxbridge factory.

many, Switzerland and Austria the many well established firms had not formed into combines such as the WPM and were able to absorb the impact of the new 20th-century movements and participate with them. For example, Salubra Wallcovering Co. of Basle was widely known from the beginning of the century for their 'Tekko' embossed papers advertised as dustproof, lightfast and washable and, with traditional designs, the 'best substitute for silks' – still the wall-covering for the very wealthy. Yet in the 1920s they collaborated with the Weiner Werkstätte, producing a portfolio of

modern designs. The English combine, in the face of the trends of the inter-war years could only watch its wallpaper sales fall, and came to rely increasingly on the sale of paints and embossed papers.

Unlike the WPM, the CPA never achieved a monopoly. Although its prospectus initially included 85 per cent of Britain's calico printing capacity, it was unable to buy several key firms such as Steiner & Co. The CPA had spinning, plain cloth (grey cloth) weaving and dyeing capabilities, the latter immediately sold to the Brad-

ford Dyer's Association. The first three years of operation were particularly uneasy; there was lack of co-operation among the member firms, the trading figures did not improve, and inefficient units were sold off.

The CPA was reorganized in c.1903 and thereafter operated as a combine, although by 1910 it held only 60 per cent of the UK calico printing units and these supplied to such a wide variety of markets that it could not exercise a monopoly. It was only after World War I that the CPA (who, with the exception of W. Grafton, was largely printing by commission for others) issued furnishing prints under its own name. These were modern designs but did little to combat the wider financial problems of the group.

Shortly after World War I both world prices and UK printed textile exports began to fall, reaching their lowest point in c.1933 when their exports were one-tenth of their 1900 level. The UK had dominated world printed textile production at the turn of the century, and in doing so also helped to support the substantial number of leading designers who influenced avant-garde textile design (and by transference, wallpaper design). As the 20th century progressed however, the UK's textile and wallpaper industry was besieged with difficulties. Weaving was adversely effected when imports of

woollen and worsted yarns from Russia became expensive due to the Russo-Japanese war. The implementation of the National Health Service in 1912 and higher charges for paper, packaging, transportation, rates (property tax) and communications increased the burden on all textile and wallpaper manufacturers. The most badly effected, however, was the massive cotton industry – an industry which in 1900 accounted for two-thirds of all British manufactured exports. In 1904 the cotton market was cornered

The CPA design 'Cowslip', 1932, was typical of many 'modernist' textiles adapted for use in more traditional interiors. (Note that the walls are painted, not papered.)

by the Americans, forcing many Lancashire mills onto half time or into closure as raw-cotton prices soared – by 1935 the CPA had only 12 plants working.

While it can be argued that much of the work of these English mills was not of 'modern' design, the prosperity and stability they had created engendered a forward-looking attitude among UK textile manufacturers as a whole and at the same time attracted attention to British products. As the basic industry collapsed, so too did confidence in British design.

Large scale industries also existed in America, where 40 amalgamations occurred between 1919 and 1933 alone, and many of these firms were similarly hampered by size. Both countries were, like Europe, affected by the economic instability which characterizes the inter-war years and both were troubled by industrial disputes. In England the miners' strike of 1912 and the general strike of 1926 severely disrupted all trade and crippled the Welsh woollen industry in particular. In America, the Lawrence strike of 1912 paralyzed an entire New England community when weaving stopped for a year.

On the whole, Europe had not developed its industries along the same lines: the concentration of printing firms in Mulhouse and silk weaving firms in Lyons were indi-

vidually owned. In Switzerland, the tradition of family-owned firms remained strong (as it still does today) and against this background the practice of putting out work to weavers survived. In the Zurich area, for example, weavers typically worked in groups of five or six, employing ten to twelve swivel looms with hand-operated Jacquards. Although largely used for traditional patterns, such looms were capable of weaving innovative designs, as evidenced by the swivel loom pieces produced in the 1930s by Heinz Otto Hürlimann, a Bauhaus trained weaver.

The French weaving industry entered the 20th century with a 200-year-old reputation for the most fashionable silks. These were produced from the early 19th century on hand-operated Jacquard looms, of which 17,000 were still in use at the beginning of World War I. Unlike the power-looms and simpler hand-looms of Britain and America, these complex looms for highly-patterned luxury fabrics were incapable of adapting to War production, and equally had difficulty in capitalizing on the immediate post-war boom. In silk fabric production, particularly for the fashion industry, America and Japan soon became the major suppliers. Louis Gueneau in 1923 in his study of *Lyon et le Commerce de la Soie*, admitted in the face of

Semi-sheer curtain fabric by Paul Rodier, c.1928. Rodier's fabrics were used by decorators such as Paul Frankl in America and Betty Joel in England.

America's consumption of two thirds of the world's production of raw silk in 1923 that *"Lyons has undoubtedly been outclassed in terms of quantity by the American fabrics"*. Thus when Paul Rodier proposed in *The Romance of French Weaving* (1936) that the French had made a conscious decision after World War I to continue with quality (hand) as opposed to quantity (power) weaving he was choosing to ignore the shortages of raw materials, rapidly increasing prices and France's limited number of power looms.

Post-war reality actually left the French with two options. Rodier's was one, taken by the fabricants closely associated with the Parisian high-fashion houses who contributed significantly to the French domination of 'high-style' in the 1920s. The alternative, more commonly selected

by furnishing fabric manufacturers, was to lower the cost of their product by turning to lower cost fibres. Thus, by 1920 Lyons had increased by 20 times its pre-war use of artificial silk, which by 1938 accounted for over 70 per cent of their fibre consumption. In the wake of the French success in the promotion of a luxury style, these manufacturers led the way towards the acceptance of artificial fibres and thus both alternatives proved equally viable and equally influential in the development of furnishings in the inter-war years.

The introduction of man-made fibres plays a major role in the changes in the textile industry during the 20th century. In fact, the shape of the post-World War II industry was at one point largely determined by the structure of the synthetic fibre manufacturers. However, this dramatic impact was a long time developing. As early as 1664 an English scientist, Robert Hooke, suggested that the work of the silk worm could be duplicated mechanically, but nearly two hundred years passed before experiments employing pulped cellulose were undertaken successfully. George Audeman of Lausanne took out a British patent in the mid-1850s which was largely ignored due to inherent instabilities in the resulting fibre. This initial problem – of flammability – was solved by Sir Joseph Swan, who patented his nitro-cellulose process

in 1883. However, Swan applied his process to electric lamp manufacture and it was a Frenchman, Count Hilare de Chardonnet, who patented a similar method two years later for fabric production and established the first factory for its manufacture at Besançon. The last 25 years of the 19th century witnessed numerous patents taken out all over Europe; spurred on in part by the favourable reaction to nitro-cellular fibre fabrics exhibited at the Paris exhibition of 1889, after which the so-called 'Chardonnet silk' was manufactured throughout Europe and elsewhere.

Among the most notable of these patents was one of 1890 by Depaissis, who employed the model of a Swiss method of 1857. Depaissis' cupra-ammonium process largely overtook Chardonnet's silk and itself was, to a lesser extent, overtaken by the work of English chemists C.F. Cross, E.J. Bevan and C. Beadle. These men patented viscose in 1892, drawing on

discoveries already made by Schutzenbergen in 1865 and Franchimont in 1879.

The first viscose yarn was exhibited in 1900 at the Paris International Exhibition and once the centrifugal spinning box was invented by D.F. Topham, the major form of regenerated cellulose fibre had been launched, to be known by various names such as 'art silk', until the adoption of the name rayon by the Americans in 1924.

The UK rights for cellulose fibre production were purchased by Courtauld's in 1904, who also almost wholly financed the American Viscose Company, the first of America's commercially viable viscose plants, which operated from 1910 until 1941. At least two other American ventures preceded Courtauld's, but these were bankrupt by 1910.

Despite such uneasy beginnings, the man-made fibre industry was well established by the 1920s, initially

dominated by the Europeans who financed four of the six new companies formed in the United States in that decade. Courtauld's also began viscose manufacture in Canada in 1926: a prelude to their rapid expansion some 20 years later. Also growing were AKU in Holland, Glanzstoff in Germany and CTA in France. Support for American manufacturers also came from British Celanese, the first UK company to develop cellulose acetate processing.

While rayon is a staple fibre (like cotton, wool and linen, requiring spinning), acetate is a filament yarn, extruded in a form which, of all the man-made fibres, most nearly approximates silk. However, despite extensive studies and earlier discov-

Courtauld's experimented with many combinations of yarns, as in this sample of a viscose/cotton furnishing fabric woven in their Halifax mill in 1929.

ery, acetate was not taken up until 1901 when Cross and Bevan drew attention to the work of chemists in Germany.

Although acetate requires no spinning, it did require new dyestuffs. Viscose rayon, on the other hand, absorbs dye better than cotton (and cupra-ammonium even more so) and this factor contributed greatly to the early dominance of the viscose process over the acetate in furnishing fabrics. However, both continued to be produced in quantity until the mid-1960s when the manufacture of acetate fell to an insignificant amount. In the early 1970s both acetate and viscose were eclipsed by synthetic fibres, that is, those produced entirely from chemical substances, rather than 're-arranged' natural substances.

The first synthetic fibre was Nylon, towards which E.I. du Pont de Nemours & Co. (du Pont) began research in 1928. Ten years later an $8,600,000 plant was started in Seaford, Delaware, producing the first yarns in the last month of 1939 and thus not free for use in furnishing fabrics until after the War. Polyester, too, was experimented with in the 1930s. J.W. Whinfield and J.T. Dickson obtained the first successful fibre in England (where it was known as Terylene) and in 1946 du Pont acquired the rights of manufacture in America (where it was known as Dacron).

Thus, despite experimentation on synthetic fibres, the man-made fibres viscose and acetate remained the new yarns between 1900 and 1940. They were initially more widely applied in the fashion industry, where acetate in particular found use in undergarments and, later, women's clothing. The lack of an agreed name for viscose until the mid-1920s seems to have detracted from recognition of its unique qualities and the reference to it as 'artificial silk' served only to emphasize that it was a cheap substitute for a luxury fibre.

The low cost of man-made fibres in relation to silk was critical, however, to their eventual wide-spread use which increased from the end of World War I, when costs began to climb rapidly. When a number of furnishing silk manufacturers who exhibited in Paris at the international exhibition of 1925 included all or part-rayon cloths, they were no doubt demonstrating their attempts to cut costs. By 1928 (by which time prices were falling) the cost of silk was still over three times that of acetate yarn and almost nine times that of viscose staple. Here the lower cost of rayon should be noted as a further contribution to its greater use in comparison with acetate. In addition, once the prices bottomed out in 1932, all natural fibre costs afterwards gradually increased, while man-made fibre costs continued to fall. Thus

during most of the 1930s rayon competed favourably with the lowest priced yarn (cotton) while acetate dropped to below the price of worsted yarn. This trend continued into the post-World War II period when, in 1962, for example, acetate replaced rayon as equal in price to cotton, and rayon itself was one-third the cost of either.

Although the substances themselves were relatively inexpensive, the integration of man-made fibres into the textile industry was not. New machinery and methods were required to protect the fibres during any wet process and these initial problems easily offset rayon's greater receptivity to dyes, an advantage which acetate did not share. The necessary mechanical developments occurred largely in England and America, the latter gaining a significant lead in mmf technology as a result of the 1914–18 war, after which they became its largest producer.

Improvements in dyes and dyeing techniques for man-made fibres were also obtained, although their metallic appearance, particularly noticeable in the deeper, brighter shades, continued to cause concern. As late as 1946, Enid Marx was to comment in an essay on furnishing textiles in the 'Britain Can Make It' exhibition that many shades of dyed, man-made fibre yarns were still aesthetically poor.

It is no wonder, then, that *Ideal Home* of April 1929, while reporting the significant increase in the use of rayon in modern French furnishing fabrics, also recorded the new vogue among them for reflective elements of design as opposed to colour. Eight months earlier the same magazine had discussed the effect of electric light on colour, concluding that rayon was particularly suited to non-tinted illumination, or what *Ideal Home* called electrical 'cubist lighting'.

In America, where the mid to late 1920s trend for black with white or silver was seen as originating from the Viennese style of the previous decade, the same concentration on form and contrast occurred. Helen Churchill Candee was to describe a typical late 1920s modern room in her 1930 publication, *Weaves and Draperies* as having a:

"floor of jade-green lac on which is thrown a rug of black lightly broken with an eccentric line of grey, walls and ceilings are silvered, curtains are of chartreuse gauze, and lighting flows from shafts of frosted glass, applied to corners. When the problem comes of a covering for furniture, recourse must be made to the woven patterns in rayon and cotton where the rayon threads carry the design against a greyish ground and shine like silver to carry on the effect of the walls."

Such remarks illustrate the way in which rayon reached its peak of fashion during the 1930s, making an important contribution to the appearance of furnishing fabrics in all price ranges. By limiting the tonal range to a paler, more subdued palette and playing on the contrasting surface qualities of rayon and natural fibres, the brilliance of rayon became an asset. There is little doubt that these factors increased the incidence of low colour-contrasting fabrics which predominated from c.1929

'Hasta', by Marion Dorn for Edinburgh Weavers, c.1936. Over a linen ground are woven white leaves in rayon and bright leaves embroidered in the (then) new Lumetuft process.

to 1935. Man-made fibres were, of course *machine*-made fibres, and their appearance had a natural affinity with the steel, mirrors, silver leaf, aluminium and chrome which were introduced into interiors in the interwar years.

Just as the search for man-made fibres was a continuation of 19th-century activity, so too were explorations of new yarn combinations and components. The period between the two World Wars was particularly innovative, although much of the experimental use of materials took place in crafts workshops or weaving schools, and did not enter into mass production.

In Germany and Switzerland, where the combination of part-time teaching with studio work was widely accepted by weavers, the search for alternative substances was strongly emphasized. In this, the influences of the Bauhaus trained weavers such as Gunta Stölzl Sharon, Anni Albers, Margaret Leichner and Heinz Otto Hürlimann can be traced. Hürlimann, head of the weaving section of the Zurich Kunstgewerbeschule, used cellophane in some of the pieces from his own studio which he sold through interior decorating firms such as Betz and Wohnbedarf and the rural industrial shops in most major Swiss cities. Cellophane, as well as synthetic horsehair and finger-thick spun rayon, was also used by Leichner, who made prototypes for the Deutsche Werkstätten in Berlin in the 1930s.

Both Stölzl and Albers stayed on to teach at the Bauhaus as well as building a reputation for their stylish approach to materials in their own studio work. Their selection of yarns was primarily in relation to their appearance – designing of yarns by hand-spinning and dying was seldom done.

For innovation in this area one must turn to England, where explorative hand-woven lengths and hand-spun yarns were being produced at Ethel Mairet's workshop at Gospels.

By the 1930s these were produced mainly by European weavers, among them Marianne Straub, herself trained by Hürlimann. Together, Mairet and Straub visited the Hürlimann, Stölzl and Leichner workshops in 1938, resulting in the introduction of cellophane into Gospels cloths. The real impact of these efforts was to come after 1940, particularly in the teaching of Anni Albers in America and Leichner and Straub in London. Only Dorothy Liebes, with a studio in San Francisco from 1930 to 1948 (and afterwards in New York) seems to have developed a reputation for choosing unconven-

Donald Brothers cloths of c.1930, employing linen, jute and cotton.

tional yarns and materials entirely separate from the German-Swiss influence.

Within the British industry the experimentation by hand weavers was echoed in the 1930s by the introduction of mixed-content yarns such as Barlow and Jones' 'Nuralyn', a combination of rami and Fibro (Courtauld's cut staple rayon), and Ireland's linen and Fibro, as well as mixed-yarn cloths. The need to lower costs not only brought rayon into wider use, but also contributed to the increased use of rami, linen, flax and jute (wool had already been made acceptable in furnishings by William Morris). By the mid-1930s viscut (a forerunner of Lurex) had obtained limited use, principally in high quality furnishing textiles.

The initial lack of texture in rayon and its use as a contrast to natural fibres led to an increase in 'fancy' yarns – gimps, snarls, and so on – and 'self-textured' yarns such as mohair (with which Liebe's name is inextricably linked in America) and goat's hair, which was combined with wool in the influential handwoven cloths by the Frenchman, Rodier. Texture was, of course, a natural component of hand-spun yarns and thus the texturing of less expensive cloths (and wallpapers) made reference to a luxury product.

The most progressive fancy yarn doubling and spinning firm in the 1930s was R. Greg & Co. Ltd in Stockport, England. Stopford Jacks, then Sales Director of the firm, outlined a crucial sequence of events in *A Weaver's Life: Ethel Mairet*, 1983:

"...my experience with Mrs Mairet (in the late 1930s) convinced me that fancy yarns would be more acceptable to the fabric manufacturer if they could be shown to him in fabric form, the fabric being designed by a qualified weaver who had proved they were a commerical proposition on a mechanical loom".

Although it was after the War that he eventually appointed Margaret Leichner to perform this task for Greg's, the now-common practice of cloth-sampling by yarn manufacturers was first conceived in the decade which witnessed the most active influence of hand-weaving on mass-produced textiles.

In wallpaper production, the printing of aluminium papers in the 1930s seems to have been for limited novelty runs only, and technical innovations principally resulted in slight adjustments or improvements on the known techniques. Innovations in wall treatments largely excluded papers, which under pressure from the modernists had virtually disappeared from avant-garde interiors by the late 1920s. For traditional interiors, however, immitation wood-panelling and

Aluminium wallpaper – part of a scheme designed by Donald Deskey in 1933 for the Radio City Music Hall in New York.

other *trompe l'oeil* effects were made available in 'Lincrusta', a relief Linoleum-like wallcovering developed by Frederick Walton (the inventor of Linoleum) in 1877 and thereafter manufactured in Germany, England and under English patents in America.

With the exceptions of embossed wall-coverings such as 'Lincrusta' and 'Anaglypta' and textured oatmeal or 'ingrain' papers (available throughout the period), the main methods of patterning wallpapers and textiles were the same – by

'Tiger Lily' by Robert Artis, 1921. A design for an engraved roller-printed textile which indicates the fine-line detail possible with this technique.

engraved copper rollers, raised or surface rollers, or wooden blocks, the latter printed by hand. Of these, hand-block printing was the most expensive and richest in effect, particularly where one colour was allowed to fall on to another – thereby creating a third.

From the late 19th century to the late 1920s the printing of textiles and papers from the same blocks was not uncommon, particularly in the small designer-led workshops established in France just before and after World War I. In England at the turn of the century there is also ample evidence that wallpapers and hand *woven* textiles were produced from the same designs. By 1900, matching papers and printed fabrics had reached 'fad' proportions in America – suggesting that machine printing may have been involved, although the differing widths of papers and fabrics precluded the use of the same machine for both. Further, each machine-printing method gave different results on either surface.

Printing by engraved copper rol-

lers was the earliest mechanized process, applied initially to fabrics in the 1780s and remaining the major method of mass producing textiles until the collapse of the Lancashire industry in the 1950s. The fine detail of engraved rollers distinguished their product from surface and block printing, but was initially unsuccessful in wallpaper printing because the distemper colours preferred for paper printing were much thicker than the pigments used for the more absorbant, pliable textiles. At the end of the 19th century copper rollers were re-introduced for use with oil based colour on paper which, when varnished, were rendered washable, and therefore known as 'Sanitary'

Comparison of this Warner's 'Jacobean-style' design, 'Westmorland', with the surface roller printed cloth, shows the blurring effect of the wooden rollers.

wallpapers. However, from the 1840s mechanized wallpaper production relied on surface printing, in which raised brass outlines stuffed with felt carried the colour until the substitution of raised rubber (flexographic) rollers was effected gradually from their introduction in the late 19th century. The low cost of the flexographic rollers has made it the most widely used process for 20th-century, mass-produced wallpapers.

For textiles, surface printing was carried out with raised copper and felt or wooden blocks – the effect of which was to blur the edges of the colour, as can be seen by the comparison of a design and fabric printed by this method. In the 1920s, the influence of naive, loosely-drawn and deliberately mis-registered block-printed designs originating from craftsmen/designer studios cast surface printing's characteristics in a favourable light, and thus revitalized its use. Well into the 1950s it was still being used for Jacobean revival designs for the English markets.

The search for irregularity in pattern also led to the introduction of 'shadow' printing in the mid-1920s –

a mass-production method which duplicated the effect of an ikat or *chiné* by printing onto the warp prior to weaving. However, all these mass-produced techniques required the intervention of a technician, at which stage the design was often altered, if only slightly. The proliferation of small craft workshops in Europe in the 1920s may have been as much a rejection of this technical translation as a positive impulse towards hand-made work.

The need for a more direct method of reproduction is to a large extent responsible for increased interest in screen printing. Like many developments in the first half of this century, the antecedents to screen printing existed well before it was adopted by industry. In this case the forerunner was the 17th-century Japanese stencil used for kimono-silk printing. The technique was not applied in Europe until the mid-19th century, when it gained very limited and short lived use in France, Germany and Switzerland. At the end of the 19th century, hand-stencilling was used for wallpaper borders, but the single colour, shaded or striped stencil printing machine patented in 1894 by S.H. Sharp for textiles seems to have attracted little attention, despite the fact that it was adapted for spray painting.

In 1910 Mariano Fortuny patented a continuous stencilling machine which combined a fine silk supporting mesh (substituted in the mid-19th century for the connecting hairs as used in Japan) with a photographically produced barrier, which he used to produce his own textiles. However, it was not until John Pilsworth began printing banners for the American army in 1915 (using a method patented by Samuel Simon of Manchester in 1907) that its economic viability was proven. During the next fifteen years at least five further patents were granted, which improved both the method of printing and image-making and the screens themselves. Of these, the introduction of a squeegee to disperse the colouring matter was of greatest significance.

By the mid-1920s hand-screen printing on a commercial scale had also begun in France and by the beginning of the next decade its use was well established in England, Europe and America for avant-garde or experimental textiles and, additionally, wallpaper. A similar method known as pouchoir printing, employing light sensitive gelatine on glass (collotype printing) with stencilling, was at the same time introduced by the French wallpaper manufacturers, Noblis. However, neither method had the impact on wallpaper design similar to that of screen printing on textile design, the full extent of which was not to be seen until after World War II.

The advantages offered by hand-screen printing of textiles were numerous. Screen making was the cheapest form of 'engraving' – as all pattern-making for printing is called. It was far faster than block printing, it offered a simple means of producing solid coloured grounds, and designers found that in the translation of paper designs to screens no spontaneity was lost. Nevertheless as long as the method remained a hand printing technique its product could not compete with the mass-produced roller printed fabrics in terms of unit price. Consequently, the firms which initially introduced it were typically those already block printing by hand on tables that could serve equally well for both methods. These were quickly joined by a handful of new small, specialized firms such as Dan Cooper Inc. in America and Allan Walton in England (although the latter initially used a spray gun and stencil technique).

An increased use of artists and freelance designers in both countries coincided with the wider use of screen printing, but the freedom the technique allowed was only one reason for this – others were the protective tariffs placed on imports into England and America early in the 1930s. Another was the Depression, which forced many architects and painters into other employment,

Hand-printed chintzes produced by Allan Walton, c.1937. The designer of the dark ground fabric, Thomas Lowensky, was one of many painters from whom Walton purchased designs. The second fabric is by Walton himself.

including both interior and surface design (ceramics, wallpapers, textiles, carpets, book-jackets, etc.).

The publicity value of artist-designed furnishings also afforded them ample coverage in journals. For example, in *Decoration*'s review of fabrics at the 1933 British Industrial Art exhibition, more than half of the article is devoted to Allan Walton. One can sense the relish with which the writer notes designers with "*such well-known names as those of Paul Nash, Duncan Grant, Vanessa Bell, Frank Dobson, Bernard Adenay, H.J. Bull, Cedric Morris, T. Bradley, Noel Guildford, Keith Baynes and, of course Allen Walton himself*" adding, "*There has been no effort to dictate to these artists the type of design which they should produce. Each has freely expressed his personality.*"

Such publicity was, of course, beneficial to both designers and manufacturers, but left many involved in the industry unconvinced that screen printing would ever be applied to anything but the exclusive trade.

The influence of the press is nowhere better demonstrated than in the study of changing colour fash-ions; which, without colour reproductions, relied on description and association for their promotion. The introduction of vivid colours early in the century is, for example, almost always associated with the arrival of the Russian Ballet in Paris in 1909 and their production of Sheherezade in the following year. The highly coloured creation of sets and costumes for their pre-war Paris and London seasons were repeated in America and other neutral countries which they toured during the War, thus making them the most widely known example of the new, vivid palette appearing in furnishings and fashion during these years. In recognition of this, contemporary journals often referred to 'Ballet Russe colours', even though as early as 1905 such shades could be found in Vienna and Munich-designed furnishings.

The source of these colours was actually Germany, which by 1913 manufactured over 80 per cent of all dyestuffs used in Europe and America, controlling much of the remainder through the ingredients or 'intermediates' used in the making of dyestuffs elsewhere. Their dominance of the dyestuffs industry rested on their work in the third quarter of the 19th century with coal tar hydrocarbon compounds and their derivatives such as madder (alizarine), methylene blue (the first basic blue soluable in water) and malachite

green (the first green of real dyeing value), as well as with organic compounds such as tartrazine, congo red and napthol black (the first colours to have a direct affinity for cotton). The German discovery of the first antraquinone vat colour in 1901 was fast followed by rapid expansion of this groups of dyes – the fastest, clearest range – which became the most important in furnishing fabrics, particularly prints.

Patents were taken out in America to stop development of similar dyes there. The resulting German monopoly of colour-stuffs was only broken by a concerted effort made during the First World War by the Scottish firm, Morton Sundour, and afterwards by the formation of American, English and French dye-makers' consortiums. The US Government seized the German patents near the end of the War and formed The Chemical Foundation Inc. to administer them. In the UK the British Dyestuffs Corp. was founded in 1919 and was protected from 1920 to 1934 by a bill prohibiting the importation of colours already available in the UK.

The progress of the UK dyers gives an interesting insight into the importance of their industry – both to colour fashions and the fortunes of cloth manufacturers as a whole. Although efforts were made in England to replace the German supply of vat dyes and their derivatives, these dyes required much more concentration to equal the shades produced by the less fast chrome and basic ranges. Thus in the first years after the War the brilliant colours for mass-produced textiles were drawn from chromes and basics, the less expensive types of dyes. The cheapest colours – the basics – were used mainly on inexpensive export cloths or on better quality cloths where exceptionally strong colours were required. Of these, analine black was the least expensive, contributing, no doubt, to the vogue for black-grounds in the immediate post-war years. The greater incidence of alternative colour ways in mass-produced furnishings (already well established in hand-woven and block-printed goods) created additional demands on the printer – and additional financial pressures, since they often required the use of different dye-stuffs, each with its own separate method of preparation and fixing.

Meanwhile, competition in better quality markets became increasingly difficult, since the UK Dyestuffs Act resulted in higher ingredient costs within the country than elsewhere. While the UK battled with rising costs and compromises in quality of dyes for their mass-produced goods, the French high quality manufacturers were benefitting from their dyestuffs price agreements with the Swiss and Germans. The French artist and textile designer Raoul Dufy was thus able to comment as early as 1920 in *Amour de l'Art* that: "*today's printed materials are certainly more beautiful and have more variety than those of other periods because of new methods for treating colours.... Synthetic colours, contrary to widely held opinion, if treated correctly can be compared with the vegetable dyes employed in other times.*"

The British, by contrast, when reviewing their legislation in the late 1920s, were forced to concede that:

"*it was often found that in use (the British products) did not come up to the standard of what they were expected to displace and, moreover, it was generally admitted that the service given by the German manufacturers was far superior. In this line of thought it was argued that the Dyestuffs Act had forced the British producers to attempt the manufacture of too many varieties before they were really in a position to do so.*"

Geoffrey Turnbull, who recorded these comments in *A History of the Calico Printing Industry of Great Britain* (1951), indicates a further factor which brought the once dominant British mass-producers into difficulties: "*what effect the change in supplies (of dyes) and the poorer*

qualities which at times were received actually had with regard to the fall in the export figures for prints, is a matter for conjecture alone."

By the mid-1930s a good range of colours could be obtained in Europe, America and England. The growing importance of fastness to light and water brought vat dyes to the fore, but the rapid increase in the costs of dyestuffs between the Wars led everywhere to economies – weaker solutions of dyes (i.e. paler colours) and fewer colours in any one design, a trend also followed by wallpaper. In the selection of these more limited, paler palettes, the work of craftsmen using natural dyes is evident.

The progress of furnishings between 1900 and 1940 can therefore be seen from several angles: the economic pressures which led towards the use of rayon and the restriction of colours and their intensity; the artist/craftsman workshops whose textures, colours and informal, spontaneous designs influenced the industry; and the formation of large-scale firms, whose cumbersome structure eventually left markets for new, smaller firms to fill. Throughout this period the interaction of artists/craftworkers and industry remained strong – even if sometimes indirect – as the styles they mutually evolved indicate.

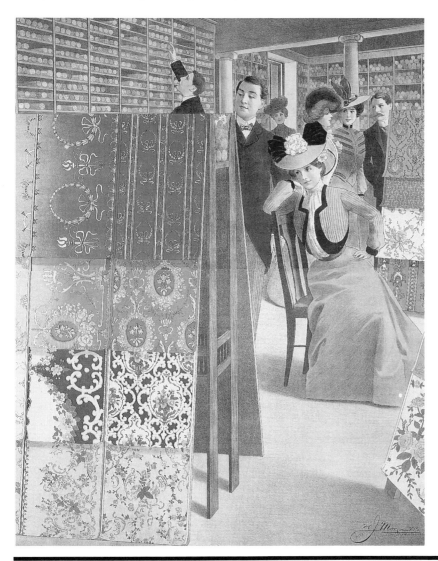

Colour lithograph produced by J. Morgan & Co., Cleveland, Ohio, depicting an American wallpaper showroom of c.1900. The variety of traditional designs, several with related borders, was also typical of European mass-produced papers of the period, although the showroom itself was not.

TOWARDS NATIONALISM

- DESIGN: 1900-1920

AT the beginning of the 20th century, enthusiasm for British wallpaper and textile design was at its apex. In Paris, British goods were offered side by side with the work of leading French textile designers such as George de Feure and Eugene Galliard in Bings' influential shop L'Art Nouveau, as well as in La Maison Moderne, opened in 1897 by Julius Meier Graefe, a German art critic. That Liberty's Paris shop remained in operation until 1931 testifies to the continued appeal of British designers abroad. Nevertheless, the diminution of their dominance was signalled at two crucial exhibitions in 1900, one in Paris – the Universal Exhibition – and the other in Vienna – the Eighth Exhibition of the Secession, devoted entirely to decorative arts.

The Paris exhibition was part of a series of international exhibitions at which the British decorative arts were well received (Glasgow, 1901; Turin, 1902; St. Louis 1904; and Christchurch, New Zealand, 1906–7). However when objects from the Paris exhibition were shown at the Victoria & Albert Museum in London, Lewis F. Day and Walter Crane were outraged by the continental designs.

Both men were then at the peak of their careers as wallpaper and textile designers. Fiona MacCarthy suggests, In *All Things Bright and Beautiful* that such criticism demonstrates insularity, distrust of extremes and dislike of the new and foreign. It is true that in France and Belgium (with Italy and Spain following their influence) Art Nouveau developed its most luscious and organic expression; that in Germany, Finland, Austria and Scotland the most geometric, constructed forms occurred; and that the English late Arts and Crafts style could be said to fall stylistically between. The furnishings of the middle classes in England between 1900 and 1905 can be recognized by a reserved and structured use of rhythmic outline, some of the most striking of which were printed fabrics produced by Steiner & Co. However, 'old fashioned' or 'conservative' are adjectives unsuited to these textiles and wallpapers, and there is no evi-dence that their designers were insular, although they could perhaps be accused of a certain degree of arrogance which derived from the strength of their industry and its success abroad.

What remains, then, is the prejudice against non-English design, confirmed by Linda Parry's observation in *British Textile Design*, Vol III, that: *"Voysey's dislike of the movement was founded on the false premise that the style had originated abroad, because of the large number of foreign designs being imported into Britain for production by British manufacturers."*

But a dislike for the foreign was not unique to the English. One of the principle purposes of the Secession exhibition of 1900 was to demonstrate that Austria had its own decorative arts style. Josef Hoffmann, the Viennese architect who promoted the exhibition, proposed:

"... to display works created abroad so as to let them compete with domestic production in the field of handi-

craft, as we had earlier done with pictures and items of plastic art (in previous Secession exhibitions). Handicraft strives to achieve an identical goal within any nation: TO IMPART APPROPRIATE FORM TO MODERN PERCEPTION. But in the course of this process national characteristics come to the fore...... I look forward to great benefits from a comparison between our own and foreign work."

Watercolour design by Eliel Saarinen for Suir-Merijoki's library, 1903. The curtain and upholstery fabrics are embroidered and the walls stencilled. The colours were chosen to reflect the owner's personality.

A block-printed linen produced by G.P. & J. Baker, London, in c.1908. The design was purchased from 'Siebers' in Vienna, and shows many characteristics of Hoffmann's 'severe' designs for the Weiner Werkstätte.

On show with the Viennese work were interiors by the Belgian architect/designer Henry van de Velde, Maison Moderne, Paris; C.R. Ashbee's Guild of Handicraft, London and from Glasgow, Charles Rennie and Margaret Macdonald-Mackintosh and Frances and Herbert McNair. Ashbee's workshop community with a school attached to it had been founded in 1888 and was of considerable interest to the Secessionists who were shortly to establish their own workshop. Both Ashbee and C.R. Mackintosh were architect-trained and of the two, the latter's reception in Vienna is the most revealing – for the extent of Mackintosh's influence on the Viennese decorative arts is still being debated.

To the uninitiated there certainly appears to be a stylistic link between the Scottish and Viennese approach to interiors, and so too, with the work of Eero Saarinen in Finland. Little use was made of printed or patterned woven fabrics, although it is known that the textile and carpet manufac-

turer Joh. Backhausen & Sohn collaborated with Hoffmann for the 1900 exhibition. Instead the Scottish, Viennese and Finnish interiors shared the use of elongated lines and a rich palette, with walls stencilled or decorated with wall hangings, often hand embroidered, as too might be the curtains, and cushions. Even so, the Viennese press reports concerning the Mackintosh/McNair room reflected attitudes which helped to promote the subsequent development of wallpaper and textile design in Vienna.

A number of newspaper reviews are quoted by Werner J. Schweiger in *Weiner Werkstatte – Design in Vienna 1903–1932* to substantiate that the

"'national character' claimed by the Exhibition Committee was recognized and praised beyond the circle of enlightened, progressive art critics. It was also seen as clearly distinct from that of the output of visiting artists, whether these were welcomed or treated with indifference."

The Scottish contribution was described by reviewers as : *"a torture chamber"*, *"a hellish room"*, *"too bizarre to be beautiful"* and *"the workshop of a modern warlock."* Here is outrage to match that of Crane and Day. More ironic still, is that the British press reported that the Scottish room was a critical success.

In these responses to both exhibitions can be found signs of nationalism which was to develop into a prominent feature of design in the 1920s, when competition for reduced markets became particularly fierce. The Germans too had quickly recognized the value of good design and the need to promote a strong national style. So active was their campaign *"to wrest from British craftsmen and designers their supremacy in the applied art campaign"* that *The Studio* felt compelled to comment so in 1901.

The fact that nationalism gradually affected both the appearance and contemporary criticism of design was to be expected in a period during which Europe was becoming politically unstable. Following Queen Victoria's death in 1900, a remarkable number of royal deaths, added to by the anarchists' assassinations, virtually eliminated the network of Victoria's cousins and offspring which had provided European states with a common bond. While the battle for design supremacy could have been fought on other grounds, nationalism, or patriotism, was a natural arena provided by the unsettling social and political mood of the first decades of the 20th century.

As with most attempts to win trade, the nationalist propaganda was more fiction than fact, for throughout the 20th century exam-

ples of foreign–originated design can be found in every country. The campaign to which *The Studio* referred included the German Government-financed study of English architect/designers. This seven-year investigation was carried out by Hermann Muthesius and culminated as the three-volume *Das Englishe Haus* (The English House). In 1904, the year in which the first volume was being published in Berlin, Muthesius acknowledged that *"the whole of our movement is based on the results England achieved from 1860 up to the middle of the 1890s"*.

Three years later Muthesius helped to found the Deutsche Werkbund (DW), a workshop dedicated to the improved design of German machine-made products. However, neither printed textiles nor wallpapers were undertaken by the Werkbund prior to World War I. Consequently, German manufacturers continued to purchase designs from their established sources – which most certainly included Belgian and English designers. If the Deutsche Werkbund had any impact on German wallpaper and textile design it occurred indirectly, as a result of the inclusion of the Weiner Werkstätte (WW) among its founder members, together with a large number of other Austrian artists, craftsmen and commercial firms.

The Weiner Werkstätte was

founded in 1903 by Josef Hoffmann and Koloman Moser with the financial backing of Fritz Waerndorfer, the son of a wealthy textile manufacturer. It was closely aligned with the Viennese artists association, the Secession, founded in 1898, and the Kunstgewerbeschule: many of the WW designers were also Secession exhibitors and Art School teachers. The WW stressed craftsmanship – the designer working directly with the executants to produce individual pieces – and thus differed from the DW and its indirect successor, the Bauhaus, which took a similar idea further, with its hand-crafted work designed as prototypes for eventual mass production. Nevertheless, it was the WW which, of the two, influenced mass produced wallpaper and textile design into the 1920s and '30s.

Both Moser and Hoffmann had collaborated with Backhausen at least two years prior to the 1900 Secession exhibition (Moser providing more designs in the first few years).

From 1905 the WW was able to produce its own hand-blocked and painted textiles, but this did not bring the collaboration with established manufacturers to an end. Backhausen, who in the meantime had supplied the textiles for Hoffmann's Hohe Warte villa interiors, went on to produce textiles by over 80 WW designers, the majority between 1905 and 1923. Some indication of the

wealth of ideas which emerged from the WW textile workshop is given by the following figures: Hoffmann 6,204 patterns; Moser 330, Kitty and Felice Rex 76 and Dagobert Peche 2,766.

Peche joined the workshop in 1915, two years after the WW began to operate its artists' workshops. There artists with no workshops of their own could experiment at the WW's expense with the proviso that the latter had first choice of purchase. The WW benefitted enormously from this arrangement and it may well be that the eclecticism which was provided by the numerous artist/designers contributing to the textile workshop suited the industry. Certainly it suited at least 11 other textile manufacturers in Austria alone (including Phillip Haas & Söhne and Indanthrenhaus), who together employed 16 WW designers on a freelance basis.

Hoffmann's textiles from 1903 to c.1910 have been labelled 'severe' and align easily with the interior details of Mackintosh, whose own textile designs were to come later. By the middle of the first decade of the century, Hoffmann's rectilinear, simply coloured textiles could be purchased by the discerning in Europe, the UK, and through Austrian manufacturers' export agencies, in America. The style was also immitated by others. G.P. & J. Baker (London) were, for example, able to buy a small group of severe

designs from Sieber's (Vienna) in 1907.

While manufacturers were themselves spreading the Weiner Werkstätte style through their exports, exhibitions and art magazines continued to play their part. As a result of the Imperial Royal Austria Exhibition in London in 1906, *The Studio* devoted a special issue to 'The Art Revival in Austria' and while unable to pass over the opportunity to comment that: *"Professor Hoffmann's great aim is to follow in the footsteps of Ruskin and William Morris"*, the magazine

'The Fritillary', designed by Lewis F. Day in 1906. The squares in the petals show the influence of the Weiner Werkstätte.

nevertheless concluded that: *"from an artistic point of view, great success has been achieved."*

Almost immediately, the chequerboard motif associated with the early WW was being produced by British designers. The American artist/craftsmen and avant-garde manufacturers also learned of the Viennese style through *The Craftsman,* published in New York under the editorship of Gustav Stickley. Many articles were prompted by the international exhibitions which, from 1903, included WW products in the Austrian section.

Naturally the most extensive exchange of objects, ideologies and styles occurred among the middle and northern European states, where geography made communications easier. Thus, the principle WW exhibitions between its foundation and the 1925 international exhibition in Paris were in Germany, Switzerland and Sweden.

The first major exhibition outside their own Vienna showroom was not in Austria, but in Berlin, at the Hohenzollern Art and Craft House – managed from 1899 by Henry van de Velde. The first publication concerned with the WW's output was timed to coincide with this exhibition's opening in October 1904. It appeared in *Deutsche Kunst und Decoration* whose publisher, Alexander Koch, secured sole German repro-

This Weiner Werkstätte design for a fabric employs flattened, naive motifs also associated with Art Munichois.

duction rights for WW work. In total, over 1,000 WW illustrations were used between 1904 and the early 1920s with 12 special issues entirely devoted to the WW between 1904 and 1911. This alone gives some indication of the close relationship which developed between German and Austrian designers and craftsmen during this period.

The association between Germany and Austria was to badly affect Western European attitudes towards Viennese decorative arts during the wave of anti-German feeling after World War I, and, as a consequence, the pre-war impact of middle-European design on France and, to a lesser extent England, was quickly forgotten. However, both stylistic and documentary evidence abounds.

When the Munich Exhibition of Applied Art drew unusually large crowds during its 6-week showing in Paris in 1910, the French critics launched a bitter – and patriotic – attack. Such attacks were necessary because, as Martin Battersby pinpointed in *The Decorative Twenties*, the exhibition: *"had resulted in record sales and had a disturbing effect upon French artists and designers whose inborn conviction of French prominence in the decorative arts was shaken."*

The complete decorative schemes by Richard Riemerschmidt, Von Seidl, Theodor Weil and others were characterized by flattened, highly stylized motifs derived from traditional 'peasant' crafts. In its interpretation of Naive or Primitive styles, the Art Munichois reflected trends also already established in Belgium and Scandinavia, but most prominent in Austria. Nationalistic sentiments – roused in the French by the success of the 1910 Munich exhibition – quickly produced a response among the minority who recognized the source of the new fashionable designs of the period.

One of the most highly acclaimed French designers to take direct inspiration from middle and eastern Europe was the fashion designer, Paul Poiret. He travelled widely between 1909 and 1912, including visits to Russia and, on several occasions, Germany. His visit to the international exhibition in Rome, 1911, prompted

him to seek introductions to Hoffmann and Gustav Klimt which he took up shortly afterwards in Vienna. There he bought extensively from the WW, the school of Art and Craft and interior decoration firms. As a consequence, textiles by Hoffmann and Wimmer were part of Poiret's 1912 fashion collection, although this was not the first occasion on which the Viennese style could be seen in Paris fashions.

Among one 1908 collection was a dress which was described by the magazine *Weimer Allemeine Zeitung* as having, *"a dark grey velvet background chequered by black lines into alternating squares"* which was

'Roses', a wallpaper by Atelier Martine showing the naive style for which they became known.

'Iselberg', a Weiner Werkstätte wallpaper, designed by Irene Schaschl in c.1920. A similar paper was used in the WW New York showroom in 1922.

"very familiar to the practiced eye of the Viennese lady. It is the registered trademark of the WW. This strictly geometric sign adorns all the packaging of the Werkstätte, both paper and boxes."

The blurring of lines between fashion and furnishing textiles has often been credited to Poiret but it had occurred earlier, in Viennese Secessionist 'rational' dress, and was much more than a phenomenon restricted to textiles. Virtually any surface decoration, as the example above indicates, could provide designs for a myriad of uses, particu-

larly in workshops where artists and craftsmen worked together.

Nevertheless, in France it was Poiret who epitomized the 'blurring of lines' trend when his combined interest in the Weiner Werkstätte and children's schools in Eastern Europe led him to found Atelier Martine in 1911. The pupils – girls of about 13 years of age – were encouraged to draw spontaneously from nature. Poiret clearly felt the results were satisfactory, for his interior decoration firm, Maison Martine, was founded a few months later, in 1912. The Martine interiors created a startling effect employing wallpapers (printed by Paul Dumas), textiles, embroideries and rugs with large loosely drawn flower and leaf motifs. The designs supplied by Atelier Martine were also applied to a variety of other items, from paper fans to furniture and in this universal application of image to object it parallels England's Omega workshops (1913–1919), founded by Roger Fry.

Fry's concerns were two-fold: to promote the English Post-Impressionist's style, with which he was closely involved, and to provide a small but constant wage for the artists with whom he associated in London.

Aside from the decoration of screens, furniture, ceramics, toys, dresses, lampshades and, in fact a similar variety of items being pro-duced by the avant-garde workshops throughout Europe, the Omega artists designed six printed linens and one Jacquard-woven fabric in 1913. The prints, by Roger Fry, Duncan Grant, Vanessa Bell and Frederick Etchells, were produced in France by Besselievre, while Vanessa Bell's 'Cracow' was woven by A.H. Lee & Sons in England. Alongside these were a variety of hand-dyed and painted textiles, collages and embroidered panels (most by Grant) together with batiks produced by a Manchester firm for export to Africa.

In appearance, there is little to connect Omega with the workshops in Europe, yet in common with them, Omega's energetic lines and loose brushstrokes tried *"to keep the spontaneous freshness of primitive or peasant work while satisfying the needs and expressing the feelings of modern cultivated man."* This statement, made by Roger Fry in the preface to a c.1915 catalogue, serves to emphasize the importance of childlike simplicity in both avant-garde surface design and art of the period.

The significance of the fine arts in the development of textiles can here only be suggested by comparison of the Fauves with Poiret's Martine interiors, which shared naivety and high colour and, with Omega, what *The Times* (London) of July 9, 1913 called 'irrational gaiety'. The links between Maison Martine and the

Omega's 'Mechtild' by Frederick Etchells, 1913. The Professor of Textile Industries at the University of Leeds some time later described this design as having 'far more true "value" than any or all of the mechanized designs all too much in evidence at the present time.'

Omega were more than superficial: it may well be that Martine actually inspired Fry to form Omega. Fry must have visited the Paris shop at 107, rue Saint-Honoré while next door at the Galerie Barbazanges in July 1912 arranging an exhibition of English artists. In December 1912 he wrote to Bernard Shaw that: *"already in France Poiret's Ecole Martine showswhat added gaiety and charm their products gave to an interior. My*

workshop would be carried on on similar lines and might probably work in conjunction with the Ecole Martine by mutual exchange of ideas and products."

Despite Fry's further nationalistic comment that, *"in the main I wish to develop a definitely English tradition"*, 1912–14 is the cumulative high-point of internationalism among the avant-garde in Europe and America, represented by the full-circle of influences stretching from Ashbee and Mackintosh to the WW and Art Munichois, through Maison Martine to the Omega.

From the consumers' point of view such internationalism is further represented by the shop opened by Marcel Boulestin in London in 1911. Boulestin, a French journalist, sold textiles and wallpapers by Martine, André Groult, and Paul Iribe, textiles from Darmstadt, Munich and Vienna and wallpapers from Berlin and Florence. These were sold alongside African art and French vases, pottery and glass to London's fashionable society, many of whom were also Omega's customers. Many of the textiles and wallpapers – irrespective of their country of origin – would have employed elements of design originated at the Weiner Werkstätte. The Viennese workshop, as the most highly organized, prolific pattern generator of the first two decades of the century, was ideally placed to provide innovation and leadership in decorative motifs. Its other intellectual and cultural activities were widely acknowledged among European and American artistic and intellectual circles and this too, attracted attention to the Viennese craftsmen and artists.

Nevertheless, that the ecclectic range of textile designs had so much exposure outside Austria did not, in the end, lead to recognition of the 'national character' which Hoffmann sought. While the 'practiced eye of the Viennese lady' might have recognized the chequerboard motif as a WW design, this design, like many others from the same workshop, entered the vocabulary of European designers and manufacturers to be presented to a public as simply another style – one which they hoped would be commercially viable.

As the 20th century progressed there were fewer who could afford *not* to make money through their artistic ventures. Not surprisingly then, it is with some pride that Boulestin related in his autobiography that the first nine months of sales and

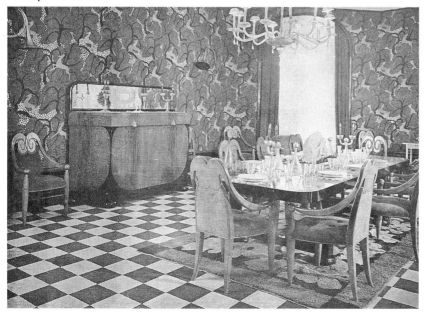

Dining room by Atelier Martine c.1923. Such interiors were consciously luxurious and their design seldom took into account the needs of mass-production.

commissions brought in £3,000, accounting perhaps for the fact that the foreseen Omega-Martine association never materialized. This success, like the financial support for the craft workshops and 'artistic' interior decorators across Europe, came from a small group of patrons from the upper classes, and the co-operation of (and influence upon) industry was not their principle aim, except in the case of the German workshops, which by the immediate pre-World War I period had succeeded with furniture in combining good design, quality and industrial production.

The results obtained by the Germans naturally attracted the attention of leading designers and manufacturers in other countries and between 1912 and 1914, the Deutsche Werkbund model directly influenced Austria and England. In 1912, the DW held its fifth annual conference in Vienna, for which the local Museum of Art and Industry mounted an exhibition of Austrian craft and industrial art. The success of the exhibition and conference, at which *the significance of the Werkbund idea for Austria* was discussed, prompted the immediate founding of the Austrian Werkbund. These two were not the only institutions of their kind, (Sweden and Switzerland were shortly to have similar organizations) but the relationship between the German and Austrian Werkbunds was

unique and, in the avant-garde styles of their respective country's wallpaper and textile manufacturer, mutually influential.

This relationship can be seen through the WW wallpaper designs, which were not produced until 1913. Nevertheless, these had an impact equal to that of their textiles, no doubt partly because the collabora-

Above: A roller-printed textile produced by William Foxton in 1920 thought to have been designed by C.R. Mackintosh; and, below: a 1910–14 illustration, showing Foxton's woven curtains and bedspread.

tion was instigated by the manufacturers themselves and the results were thus distributed widely. It is said that the Austrian firms were encouraged to seek avant-garde design by the profits German manufacturers obtained with designs by their own artist/craftsmen such as Peter Behrens, Otto Eckmann (a prolific designer whose work was printed by firms such as Englehardt in Mannheim) and Richard Riemerschmid, an influential architect and designer, who from 1912–24 was head of the Arts and Crafts School in Munich.

In Austria, Joseph Maria Olbrick (a founder member of the Vienna Secession) had designed wallpapers in the 1900s, but it was not until an exhibition of Austrian wallpaper, Lincrusta and Linoleum in mid-1913 that Austian artist-designed wallpapers were publicly launched. The exhibition, organized by the Austrian Museum of Art and Industry in Vienna, included designs both *for* the WW and *by* nine WW and several Arts and Crafts School designers for the manufacturers P. Piette (Prague), Julius Jaksche and Thausig & Comp.

The Prague manufacturers were responsible for the WW's own stock designs and among the designers were eight members of the newly formed Austrian Werkbund, two of whom were also in the Deutsche Werkbund.

It can hardly be coincidence that artist-designed wallpapers appeared in Austria almost immediately after the founding of the Austrian Werkbund. Several Austrian designers also later provided designs for German manufacturers. Such work quite possibly came through their DW contacts, which were further strengthened through the Werkbund Exhibition in Cologne in 1914, where the Austrian pavilion was designed by Hoffmann in classical style. In Max Eisler's 1916 account of the Austrian Werkbund's achievements, Karl Giovanni emphasizes the extent to which the commercial production of furnishings by Viennese artist/craftsmen was the exception: *"Broadly speaking, these articles and illustrations dealing with Austrian craft output suggest that, as compared with its German equivalent, its characteristic feature is that a handicraft approach prevails over an industrial one, that imaginative originality predominates, in other words that the personal element is more important than the stereotype."*

In England, The Deutsche Werkbund-inspired founding of the Design and Industries Association

The CPA produced a number of modern stripes such as this roller print of c.1921, possibly by Constance Irvine.

(DIA) in 1915 cannot be associated with a similarly dramatic collaboration between artist/designers and manufacturers; at least, not in wallpaper and textile design. To a large extent, the integration of art within industry was already too well underway in these products, as evidenced by the output of established textile firms such as Alexander Morton and Liberty and wallpaper firms such as Essex & Co. and Jeffrey. Twelve years before the founding of the DIA, their efforts were anticipated by at least one new firm, William Foxton, founded in 1903.

Foxton's has never been the subject of intensive research, partly because its records were destroyed during World War II, yet it seems certain that its founder's principle intention was to mass-produce artist-designed textiles. H.G. Hayes Marshall, writing of his: *"old friend Mr William Foxton, who ploughed a lonely furrow,"* declared in *British Textile Designers Today* (1939) that: *"No man ever had a greater desire to improve the standard of design in Furnishing Textiles in England. No man ever worked so hard for this end... (or) had so little help and encouragement. His only mistake was being 20 years too soon."*

Hayes Marshall's final remark could not have been more prophetic, for little is known of Foxton's textiles until 1918, when he produced at least two designs by C.R. Mackintosh (who, in the fallow period of his architectural practice between 1916–23 turned to designing textiles).

Foxton and F. Gregory Brown (an artist and textile designer Foxton purchased from in the 1920s and '30s) were early members of the DIA, whose first council included the textile men James Morton of Morton Sundour Fabrics Ltd (founded 1914 and inheriting A. Morton & Co's. furnishing fabric production), Frank Warner of Warner & Sons Ltd and Charles F. Sixsmith of Bentinck Cotton Mills. Craftsmen, architects, industrialists, furniture-makers, educators and shop owners joined the DIA, many of whom had shortly before urged the British Government to arrange an *Exhibition of German and Austrian articles typifying successful design* in March 1915, at which the WW was particularly well represented. This was followed by the publication of several pamphlets (one praising the DW).

Most DIA members were leaders in their field, but their firms accounted for only a small proportion of British manufactured goods. The largest manufacturer, the CPA, seems only to have co-operated with the DIA on one occasion. Together they held a design competition which singled out, among others, Claude Lovat Fraser and Prudence Maufe. Until his early death in 1923, Fraser was a painter, illustrator, theatre and textile designer whose brightly coloured, freely-drawn textiles were also produced by Foxton's. Maufe went on to have great impact through her work for Heal's Fabrics Ltd.

The majority of Manchester textile manufacturers presumably fell outside the parameters of DIA-accepted design, selling their products abroad in markets which until the early 1930s, combined a relative inattention to European avant-garde fashions with economic stability. Given this, it is little wonder that the DIA had only three replies when it canvassed 60 Manchester textile firms for fabric samples for a textile exhibition in mid-1916. Undaunted, DIA members visited factories and were actually pleasantly surprised. This experience had additional benefits, outlined in the *DIA Year Book 1964–5. "In selecting and discussing, the members gathered valuable experience of the snares of textile designing: fabrics which appear clear from nearby but muddled at a distance, fabrics whose colours speak at daytime but go dead by artificial light, fabrics convincing in design when seen flat but not when seen draped and so on."*

This summarizes the criteria by which the DIA pronounced a textile to be 'fit for its purpose' (the phrase by which the DIA is now best known), but the organization had dif-

ficulty in making these principles widely known. Such knowledge was principally for the members – the converted.

The fortunes of the DIA during these years are recorded in their Journals of 1916–19, and their main achievements are intellectual rather than practical. By 1919 their propoganda campaign had nearly persuaded the Government to found a British Institute of Industrial Art, a permanent exhibition of good design and a bureau of information. Although the former and latter were set up almost immediately after the War, the combination of all three only effectively came to fruition with the founding of the Council of Industrial Design (CoID) in 1944 and the opening of its Design Centre shop, display centre, and information service in London in 1956.

Ironically, the DIA's achievements in the textile and wallpaper industry by 1920 were well behind those of the French industry which, without the aid of a formal organization, produced the most well known artist-manufacturer collaboration of the World War I decade: that of Raoul Dufy and Atuyer Bianchini-Ferrier -- shortly to become just Bianchini-Ferrier.

Dufy began designing textiles as a result of two projects undertaken for Paul Poiret in 1911. For the first, the Pavillion de Bettard, he created

Leon Bouchet armchair with fabric by Raoul Dufy, exhibited at the Salon d'Automne, 1922, and marketed by Bianchini-Ferrier. Dufy's depiction of animals can be traced to his 'Bestiary' illustrations of nearly ten years before.

painted panels in the Munichois style, evoking Tyrolean folk art and for the second, *La Mille et Deuxieme Nuit* (The 1002nd Night) he contributed to

the decoration of a large awning in the oriental style. For the latter, a society fête-cum-publicity stunt, Poiret also wanted Dufy's designs on dress

silks and so set up the Petite Usine (little factory). This modest workshop did not survive longer than a year, but with the second-hand equipment and the help of a chemist and girls from the Atelier Martine, Dufy quickly made his stylistic contribution both to Maison Martine interiors and Poiret fashions.

The fabrics were either hand-painted panels or lengths of fabric hand-printed with wooden blocks, a process with which Dufy had already gained first-hand experience as an illustrator of limited edition books. Indeed, while some of Dufy's early textiles derive from the painted Tyrolean-style panels of the Bettard pavilion, many more utilize the stylistic technique seen in his wood engravings for Guillaume Apollinaire's *Le Bestiare ou Cortège d'Orphée* of 1911, with naive, flattened, white motifs densely set on a black ground. Many later textile designs employ images from *La Pêche*, *La Moisson*, *L'amour* and other individual woodcuts of c.1910.

The widespread interest in woodcut illustrations and revival of fine art presses and their impact on surface design up to c.1930 should not be underestimated. In France Marie Laurencen and Robert Bonfils are two of several noted wood-cut illustrators who brought a similar approach to their wallpaper and textile designs. Among early 20th-

'Oranges and Lemons Say the Bells of St Clements' by Dorothy Hilton for Jeffrey & Co. in 1902. Nursery papers and fabrics illustrating figures from popular children's stories have been produced throughout the 20th century.

century English wallpaper and textile designers, Crane was equally regarded for his illustrations.

At the Paris Exhibition of Decorative Arts of Great Britain and Ireland, 1914, book illustrations and hand-printed papers could be seen side by side with cottons and velvets showing African, Persian and late medieval influences – influences which paralleled those of many European designers. Also of significance were the book illustrations and bindings by artist/designers in Munich and Vienna, where the bookbinding department was the first specialized

workshop at the Weiner Werkstätte. However, it was the results which Dufy achieved with his wood-cut-like silks that were quickly noticed by Charles Bianchini, as was the effect of the colours which Martine girls applied from wooden blades with deliberate awkwardness.

Bianchini-Ferrier, a long established Lyon firm, produced both printed and woven silks and were already supplying Poiret in 1911, when Charles Bianchini (resident in Paris as the firm's Commercial Director) would have seen Dufy's textiles. Rene Simon Levy examined the Bianchini-Ferrier records and in the catalogue to the Hayward Gallery's (London) 'Raoul Dufy' exhibition (Nov 1983–Feb 1984) notes that: *"as early as October 1911, Bianchini's flair (at sensing new trends) was revealed with two patterns registered as 'genre Poiret'."* In November Bianchini-Ferrier designers were producing designs labelled 'Primitive', 'coarse', 'defective', 'irregular', 'naive'. Then in December, other entries are registered as 'genre Dufy'. The 20th-century manufacturer's willingness to copy whatever appeared most fashionable stems from a practice well established by the 18th century. Many will go to any lengths to obtain the designs they seek – in this case shortly afterwards a piece of fabric smuggled from inside the hem of a Poiret dress was placed in the Bianchini-Ferrier pattern book. Levy describes the swatch as:

"a piece of satin printed with bright red and orange flowers and emerald green leaves on a rich mauve background. Bold lines in a deep blue-black separate the various colours. Even in such a small fragment, the effect is sumptuous. The note reads: 'imitate these colours' adding: 'This is Parisian fabric by Dufy for Poiret'. By that time Bianchini had rightly, understood that only Dufy could successfully imitate Dufy......."

and by 1 March, 1912 had persuaded the artist to sign an exclusive contract, renewed annually until c.1928. Dufy's hand-cut wood blocks from Petite Usine had actually been passed on to Bianchini-Ferrier some months earlier and were subsequently re-used in various new colourways on a wide range of materials, a reminder of the industry's tendency to use patterns for as long as possible.

By 1913, new Dufy designs dominated the Bianchini-Ferrier range. In the same year he began designing *toiles de Tournon* – printed furnishing fabrics of linen and cotton. The toiles, executed in the same bold, crowded manner as Dufy's floral patterns, were modern block-printed references to the scenic copper plate and roller printed *toiles de Jouy* of 1760 to 1820. He may well have been inspired by the exhibition of toiles at the Musée Galliera in 1907, or by others who had already turned to an historical source for design inspiration. The same exhibition influenced the painters Dufresne and Waroquier, who started experimenting with textiles immediately, and Menu and Jalmes, who within a few years founded *Toiles de Rambouillet*, printing curtains and wallpapers which re-interpreted motifs from the late 18th and early-19th-century classical revival.

In Europe and England many of the older generation of designers, who had begun their careers working in the Art Nouveau style, sought their new, nationalistic styles in the

A stencil-printed Fortuny curtain imitating a hand-woven, late 16th-century Italian silk velvet.

revived, much simplified late 18th-century interior. The turn of the century French portrait painter, Paul Helleu, is credited with the popularization of gold and white Louis XVI-interiors because he used them as backgrounds against which he posed his sitters. However, such interiors had been in favour among aristocrats across Europe for well over a decade.

Among the French decorative artists many of the prime movers toward the 'classical' revival, were members of La Societé des Artistes Decorateurs founded in 1904. Their annual exhibitions, or salons, helped to promote the style, which – in furniture – differed from the original through the use of colours or black. That Poiret endorsed this trend is certain, for the fashion albums which he commissioned from Paul Iribe in 1908 and George Lepape in 1911 show Poiret gowns modelled against empire-style rooms.

Among those most closely associated with the movement away from Art Nouveau interiors in France where Leon Jallot, director of Bing's workshop until its closure in 1903, and Maurice Dufresne, Paul Follot and Andre Groult – all contributors to La Maison Moderne. All but Dufresne included wallpapers and/or textile design among their interests. Follot was the son of Felix Follot, a highly-regarded wallpaper manufac-

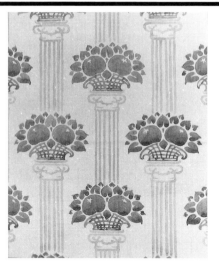

The basket of fruit depicted in this Silver Studio wallpaper design of c.1905 is virtually the same motif as that used in a poster for the Art Deco exhibition in 1925.

turer, and thus his interest in these patterns is not surprising. His pre-war furniture, now regarded as 'pure' Art Deco, includes a chair of c.1912 carved with a motif which today is associated with French decorative arts of 1910–25: a stylized basket of roses and fruit. The use of this motif was wide-spread; it can be found in the Munich journal *Die Kunst* in 1906 and a Silver Studio wallpaper design of c.1905. Follot was typical of the numerous artist/decorators in Paris during this period, who designed textiles and wallpapers to compliment particular interior schemes. Groult took the alternative approach, employing a group of craftsmen who from c.1910 produced both wallpaper and textiles for general sale.

It is worth pausing to examine a sample of the designs Groult made available in 1911, all signed by the artist – a dense Viennese-looking fruiting vine and an Empire style pattern with fountains, leaf-swags and Voysey-esque birds, both by Dresa; an all-over leaf and long-tailed bird design by Arlegle; a striped cloth with stylized baskets of roses by Louis Sue; a modern *toile* by Albert André; an all-over small, thorny vine with disc shaped flowers by George d'Espagnet; a spotted fabric with larger circles containing 'Sassanian' elephants and eagles and a *mille fleur* design of simplified pansies both by Constance Lloyd; and a dense pattern of overlapping stylized rose and leaf posies by Paul Iribe.

Such descriptions do little to bring the textiles to life, but they are included to demonstrate two related points: that while the French furniture and interior designers may have moved steadily towards their version of an 18th-century revival, the furnishing patterns used with them were not necessarily 'historically' compatible. Eclecticism was an important element in the creation of an interior which was logical yet naive.

Whether the post-impressionist's

Omega interiors or conservative middle class homes are taken as examples, ecclecticism also characterized the English search for a 20th-century style.

The revival of 18th-century patterns in furnishings occurred at least a decade earlier in England than it had in France. Initially there were two alternative types. The first were those patterns based on late 18th-century 'Indiennes' (printed cottons imitating Indian chintzes) rather than architectural reliefs or woven patterns. The exotic flowerheads, leaves and birds amid meandering stems catered well to those with timid Oriental or Art Nouveau tastes and formed a natural link between the late William Morris style and the so-called Jacobean revival, which began in earnest in c.1905 but reached its peak in the inter-war years.

The alternative, simplified Rococo plaster work, damask and brocade motifs for all types of textiles and wallpapers, arrived at much the same time. As no parallel modernized equivalent in furniture existed, the English had to rely on antiques or reproductions. The needlessly derogatory term 'Manchester chintz' is synonymous with Rococo revival patterns, especially the delicately drawn basket of flowers suspended by its handle from a ribbon, itself attached to a swag or oval of blossoms and leaves. Since, in the years leading up to and just after World War I, the Manchester cotton printers (and the WPM who produced similar designs on wallpaper) were major suppliers to the world, there is little doubt that this became the dominant style for mass-produced furnishing fabrics and wallpapers.

Among the English avant-garde designers, the work of Voysey, Day and the Silver Studio shows an ecclectic interest in historic patterns from 1900. Voysey was already employing Persian silk motifs such as the cypress tree, and from c.1900 he and Sydney Mawson increasingly used densely placed clumps of flowers or fruiting trees which can be related to 14th-century *mille-fleur* tapestries and Middle Eastern manuscript illustrations.

Other designers were similarly inspired. Arthur Silver frequently used museum collections and in 1889 arranged the production of the Silvern Series — large-scale photographs of suitable objects from the South Kensington museum (now the Vic-

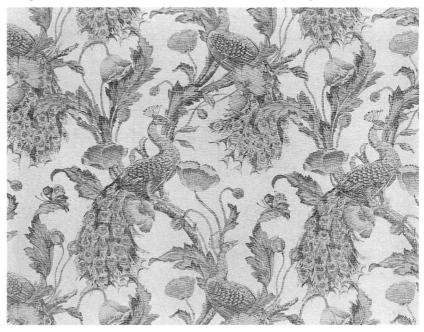

An English block printed chintz (by Warner's) and wallpapers (by Knowles) of 1896, which interprets the 18th-century meandering stem motif in a manner compatible with Art Nouveau and aesthetic tastes of the period.

toria and Albert) and other public collections. These sold steadily throughout the 1890s to progressive manufacturers such as Liberty and Simpson & Godlee, and similar motifs can easily be found up to 1914 in the ranges of Newman Smith & Newman, Alexander Morton, Morris & Co. and Warner & Sons to name but a few. The motifs were either small, conventional patterns (most typically, of Near Eastern origin) or large meandering or ogee designs taken from 15th to 17th-century Italian textiles. The Silvern patterns added to existing source material such as Sydney Vascher's reproduction of textile patterns found in 15th-century Italian paintings in the National Gallery, London and published in 1886. All of these various historical sources were used by English manufacturers up to the second decade of the 20th century.

The longevity of this type of formal patterning may be partly because it was widely used in churches, which until the late 1920s proved to be good customers for high quality silk manufacturers. It is far more likely, however, to be the result of the work of the most noted revivalist of Italian Renaissance patterns, Mariano Fortuny, who was printing and dyeing textiles in his own workshop by 1906.

Like many designers of the period, Fortuny's interests were wide ranging, embracing not only fashion and textiles but painting, engraving, architecture, photography, and theatre design. His textile designs were drawn from many sources both in his own collection and in Venice and included Oriental and European 17th to 19th-century textiles. However, he is best known for his reinterpretation of 15th-century Italian brocades and velvets, which were stencil-printed with natural colourants. Additional richness was added by printing on velvets, applying pigments over paste to give a 'flaky' effect, or adding gold or silver-coloured powder to certain areas. Unlike Paul Poiret, who consciously promoted his work via extravagant fêtes and publications, Fortuny's reputation was spread through his influential clientèle.

Needless to say, his methods were widely imitated. Well before the War, English firms such as Warner & Sons were weaving brocades with deliberately blurred 15th-century Italian motifs which echoed the effect obtained by Fortuny's printing process. The search through a wide range of historical patterns for a unique English furnishings style was unsuccessful. The mass-produced 'Manchester chintzes' were often regarded as French in inspiration and the decorative arts in Europe, while not yet dominating England entirely, had broken its ties with the Arts and Crafts movement to create new forms

– none of which were clearly dominant by the outbreak of war in 1914.

War did not bring the design of wallpapers and textiles to a halt. In Vienna, for example, Dagoberte Peche was extremely active. In 1915 he joined the Weiner Werkstätte management, immediately changing both the appearance and to some extent, the philosophy behind the WW textile and wallpaper design. The *Deutsche Kunst und Decoration* referred to Peche as, *"the master of tender, almost brittle charm, of an entrancing*

A Dagobert Peche design for Flammersheim & Steinmann's 1922 wallpaper collection. Dufy's designs of the same period show a similar use of shading and cross-hatching.

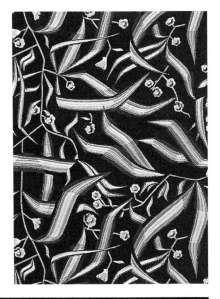

pastel shades of filmlike outlines......" and his talents were recognized while still a freelance designer, when he had a room to himself in the 1914 DW exhibition in Cologne.

As a designer of both textiles and wallpapers (and virtually everything else from Christmas tree decorations to furniture), Peche brought a lighter, wittier and – more importantly – a commercial style to the workshop. This is best exemplified by the wallpaper collections he produced in 1919 for Max Schmidt, Vienna and in 1922 for Flammersheim & Steinmann, Cologne. Peche died suddenly in 1923, aged only 37. As a result, the new commercial approach to the WW was curtailed and with it any hopes of bringing the Austrian furnishings style to real prominence in the 1920s. There is little doubt, however, that his style – which ranged from what a contemporary called '*Spikey Baroque*' to densely patterned floral motifs – found an interested audience in France.

Dufy also continued to design during the War, and had, by the end of it, and immediately afterwards, what Levy calls a "*constant need for renewed inspiration (which) led him to invent patterns.*" She further comments that some, "*if it were not for the guarantee given by Bianchini's signature would hardly be associated with his name.*" Indeed his designs – particularly those of c.1920 to 1921,

This block-printed linen, 'Zebra Stripes', was designed by Lewis Jones of the Silver Studio in 1919 and may well have been influenced by the American textiles being sold in Europe in the same year.

when Dufy lived in Vienna – could more easily be associated with Peche and other WW designers such as Irene Schaschl, Leopold Blonder, Julius Zimpel and Ludwig Heinsick Jungnickel.

The War-inspired dislike of the Munichois style in which was implicated Viennese decorative arts, was to have widespread effects. In France, Poiret was slandered anonymously in *La Renaissance* of August 1915 for his *boche, munichois, berlinois* designs. Although he sued and settled out of court, his reputation was damaged and this may well have contributed to his failure to re-establish himself with equivalent success after the War.

In America there were also anti-German sentiments during the War, but they were of a diferent kind – resulting in the Americanization of many German surnames and even the

renaming of the frankfurter as the 'hot dog'. This phase was short lived, and the Austrian and German wallpaper collections which appeared between 1919 and 1929 appear to have gained acceptance among the American avant-garde, particularly the collections by Peche (1922) and Maria Likerz (1925) for Flammerstein & Steinmann and Mathilde Flögl's 1929 collection for Salubra of Basle.

Although World War I disrupted the pattern of the European textile trade and depleted the supply of labour, it encouraged a notable attempt in America to develop an indigenous style. Prior to the War they gave the French credit for their design leadership, but it seems certain that wallpaper and furnishing textiles were more often of English manufacture or from English designs,

although there is some evidence that Cheney Bros were manufacturing silks in the geometric, Viennese style shortly after they appeared in Europe.

On the whole, however, the reserved form of English Art Nouveau and the classic revival styles co-existed for most of the period before the War, with American manufacturers contributing 'novelty' patterns such as that found on M.H. Birge & Sons' 'Batchelor's Wall Paper' of 1902. While little has been published on America's textile manufacture from 1900–1915, the Cooper-Hewitt Museum's excellent collection of wallpapers has given rise to their publication *Wallpapers in America From the Seventeenth Century to World War I* (1980) by Catherine Lynn. It demonstrates the extent to which America relied on England, with, for example, Walter Crane's 1893 'May Tree Frieze' paper still 'modern' in 1906, and the use of borders, friezes and crown decorations as widespread as they were in England. The Americans' interest in English design was such that Crane is reported to have begun designing wallpapers in 1875 as a result of American wallpaper manufacturers' pirating of drawings from his nursery books.

Such dependence did not go unnoticed. Aware of the loss of design leadership from Europe at the outbreak of World War I, Dr Clark

M.H. Birge & Sons' novelty 'Batchelor's Wall Paper' was produced in 1902. It was advertised in newspapers across America by Life Publishing Co., *who bought the copyright to this 'Gibson Girl' montage, designed by Charles Dana Gibson.*

Wissler, head of the American Museum of Natural History, decided to encourage the American textile industry to make use of the museum's collections. In his own museum he found support from Dr H.J. Spinders and M.D.C. Crawford, the latter a research associate in textiles and design editor of *Women's Wear* (now *Women's Wear Daily*). Crawford became the most visible member of a team of men which also included

E.W. Fairchild, President of the *Women's Wear* company; Albert Blum, treasurer of the United Piece Dye Works, then said to be the largest printers and dyers of silk in the world; and Henry W. Kent, secretary of the Metropolitan Museum of Art.

Between 1916 and 1922 they together produced a series of competitions, exhibitions, lectures and articles which focussed on new designs which re-interpreted the North and South American objects found in the museum. Originality *per se*, was not their objective. Crawford, writing for the journal *Asia* in January 1920, outlined their aims in terms that echo the sentiments of Europe's successors to England's Arts

Typical of the American promotion of their museums for design ideas is this page from Women's Wear Daily *of April 27, 1922.*

and Crafts movement, but made his reservations clear:

"We have not yet reached that stage in which we can be certain of our own creative impulses. We have to build an intellectual bridge from yesterday to today; from the past to the present......The time will surely come, and perhaps is not far distant, when the community taste and conception and execution will be vigorous enough to shift for itself. Then we shall in turn produce records that will become inspirations for other ages. But we must first be students and then masters....."

Self-sufficiency was far more important. Principally through personal contacts and five annual *Women's Wear* design competitions (1916–20), ideas were made available to manufacturers, who themselves were brought into closer contact with both the museum and freelance designers. By 1917 the scheme had a number of influential participants. H.R. Mallinson and Belding Bros, both silk printers; Johnson, Cowdin & Co., ribbon manufacturers; Cheney Bros, silk weavers; and half-a-dozen each from among the clothing and cotton manufacturers (the latter including Marshall Field & Co.) were among the earliest participating firms. The majority were already known as leaders in their field –

which tends to be the case – but from rather modest beginnings the concept grew into the establishment of a design laboratory at the Brooklyn Museum and later, at the Fashion Institute of Technology in New York City.

For the designers themselves there was also success. Martha Ryther, who won second place in the first competition, went on to work on a freelance basis for Mallinson and Belding. Both she and Ruth Reeves also gained notice for their batiks, which they exhibited in the Museum's 1919 exhibition. Among the 46 designers listed by M.D.C. Crawford as having entered the profession through the competitions, in *The Heritage of Cotton* (1948), was Marion Poor, who presumably was also designing batiks, for this was the medium she initially used upon arrival in England in c.1923. She subsequently became one of the leading textile and rug designers of the 30s, working under her first two names only – Marion Dorn.

Aside from the batiks, the designs produced included stepped and jagged-edged motifs derived from Peruvian and Koryak textiles and pottery, abstract symbols from American-Indian sand paintings, and geometric patterns from Southwest basketry and pottery. The resulting ribbons and dress and furnishings textiles fit well within the European Modern or

Cubist idiom which was to overtake Art Deco by the mid-1920s. Further, one must surmise that they contributed significantly to it, for Herbert J. Spinder, in the catalogue of the Exhibition of Industrial Art and Costumes at the American Museum of Natural History, notes that these, *"American goods are now (1919) selling in the discriminating markets of Paris and London."*

The American efforts to instigate their own design types are also further confirmation of the motivation provided by nationalistic sentiments. Spender's conclusion in the above catalogue encapsulates the post-war mood in both America and Europe: *"National art is the embodiment of group consciousness, it crystallizes loyalty, it is the voice of team work."*

While no single country had succeeded in formulating a style which was acknowledged in both high-quality and mass-produced furnishings as uniquely their own, the American use of a broadly based propaganda campaign; the German progress in well-designed prototypes for industry; and the French understanding of the importance of publicity stunts and the purchasing of good designs (rather than the copying of them) were to lay foundations for developments in the following decades.

FROM DIVERSITY TO DEPRESSION
- DESIGN: 1920 -1940

AS the disproportionately long discussion of the first two decades of this century should have made clear, the communication of design ideas in furnishings was as rapid as it was easy. The majority of samples were light and, if necessary, could even be smuggled away in a coat pocket. Two related points drawn from this can be taken as axioms in the study of furnishings: because the provision of variety is an integral part of the function of wallpapers and textiles, a large number of patterns are needed at any one time. This leads inevitably to the use of other furnishings as inspirations or equally to designs derived from other decorative arts or the fine arts. Thus 'image-tracking' to find the original source of a design is a fairly futile effort. The stylized rose motif as an example of the latter should serve to indicate the way in which these two factors are inter-related.

The motif itself is often associated with the Glasgow School where Jessie R. Newberry taught embroidery from 1894–1908. Depicted as a flat-tened near-circle with wedge-shaped petals, it appeared with increasing frequency between 1900 and 1910 in the work of the embroideresses such as Ann Macbeth, Johnamm McCree, Francis and Margaret Macdonald, Christine McLaren and Newberry herself. The motif may have been influenced by details from the late

19th-century 'Glasgow School' architects, for the rose features in the work of C.R. Mackintosh (Margaret MacDonald's husband) and reappears in their textile designs of 1916–23. Or it may have originated elsewhere, since it can be found in Aubrey Beardsley illustrations, Voysey and Silver Studio furnishing

Both the widely used rose motif and Voysey-esque birds can be seen in this Silver Studio 1904 design for a furnishing fabric.

'Sauvagesses', a block-printed modern 'toile', designed by Dresa for DIM (Decoration Interieure Modern), c.1921.

designs, as well as in Viennese fine and decorative arts in the years just before and after 1900. By 1910 its use was well established in Austrian and English furnishings for the middle classes and shortly afterwards it can be found in French furnishings for the same market. The translation of such a motif can often, but does not necessarily, progress from high to low cost furnishings, for it is not the pattern but the quality of a cloth or wallpaper which determines its price.

Patterns, as we have seen, can be drawn from a wide variety of sources, and there is no technical barrier which prevents a style from quickly becoming internationally available in all price brackets provided that the style-lobbyists agree. Herein lies the significance of the rose motif – not its origin — but the fact that from the end of World War I to the mid-1920s,

when it became the *leit motif* for mass-produced furnishings, it was regarded as French. In fact, many knew it as *le rose Iribe* after the French designer/illustrator Paul Iribe. The rose, together with Viennese chequerboards and revived, stylized 18th-century motifs had already experienced 10–20 years of use, but the French made them fashionable.

Whereas the early 20th-century English domination of furnishing styles was based on industrial strength combined with an active decorative arts movement, the French domination in the immediate post-war years arose by association with their fashion and furniture design.

When compared to those of England and America, however, the French wallpaper and textile manufacturing capabilities were actually very small.

Immediately after the War, the French recognized the urgency with which their *haute mode* industries had to be re-established, and succeeded very quickly in once again dominating women's fashions. A handful of Lyonnais silk fabricants such as Bianchini-Ferrier and Ducharne (who were principally concerned with high-fashion fabrics which continued, into the mid-1920s, to cross-over into furnishing) purchased and publicized artist's designs in a deliberate attempt to re-establish

A 'simultaneous' design by Sonia Delaunay for a printed fabric, 1923.

markets. They were aided by the considerable publicity given to Paris couturiers by magazines such as *Gazette du Bon Ton* and *Art, Gout et Beauté* in France and *Vogue* and *Harper's Bazaar* in America. By 1920, $11 million worth of luxury class Lyonnais silks were being exported to America alone.

Furnishings received their greatest support, however, from the the Parisian department stores Au-Printemps, Le Louvre, A Bon Marché and Les Galeries Layfette, all of which, by 1923, had their own art studios: Primavera, Stadium Louvre, Pomone and La Maîtrise respectively. As Alastair Duncan notes in his account of *Art Deco Furniture: The French Designers* this was the decade when, in France, manufacturers were, "*effectively separated from the market place*" and their grip on design development was loosened: "*the department stores moved smartly into the vacuum and assumed the role of trendsetter. The cream of France's bright young designers – Sognot, Prou, Block, Kohlmann – were brought in to direct the studios and their modern furniture was presented to a public easily persuaded that it was, at long last, getting what it wanted.*"

The department stores were joined by the smaller, specialized firms such as René Joubert and Pierre Petit's Decoration Interieure Modern, Louis Sue and André Mare's La Compagnie des Arts Français, Les Etablisement Ruhlmann et Laurent (whose principle designer was Emile-Jacques Ruhlmann), Saddier et Ses Fils – all founded in 1919 – and Dominique, founded in 1922 by André Domin and Marcel Genevrière. Textiles formed but a small part of the work produced or commissioned by these studios – wallpapers even less so, as designers as diverse as Ruhlmann, a 'traditionalist', and Jean-Michael Frank, a 'modernist', increasingly treated walls with murals, silks, metallic finishes, wood or straw. However, as competition and collaboration arose together out of this post-war eruption of support for the decorative arts, the net result was an enormous variety of French designer furnishings. There were welcomed by the critics and those who could afford them, and immitated by European and American manufacturers for those who could not.

It needed only the 1925 *Internationale Exposition des Art Decoratifs* in Paris to complete the propaganda coup for French design. The Germans were not invited to participate and the Americans declined in the belief that they had nothing to show. The British limited their contribution, having spent a great deal on their own Wembley exhibition the year before, certain also that they could not increase their exports to France (mass-produced furnishings purchased in France tended to be from the European countries on their eastern border). All eyes were thus on the French, whose domination of the Art Deco exhibition (as it is now called) was both statistically and stylistically overwhelming.

That the exhibition made such an impact derives partly from the fact that at least 75 French painters and designers of furniture and interiors are *known* to have also designed textiles and wallpapers in the 1920s (these are additional to the staff designers retained by manufacturers and the freelance studios active for most of this century, such as those run by Libert, Wolfsperger, Paul Dupont, Lucien Bouix and Pollet).

The success of the Art Deco exhibition has resulted in greater documentation of the French freelance designers than in any other country in the 1920s. Detailed studies have been made of artist/designers such as Dufy and Sonia Delaunay – who exhibited 'simultaneous' fashions and fabrics in her own gallery at the 1925 exhibition – or firms such as Süe et Mare. But less is known of professional designers such as Robert Bonfils and Leroy (who sold textiles and wallpapers, often matching, through Bouix), Jean Beaumont, René Gabriel (whose wallpaper designs were marketed by Les Papier Peints de France or Noblis), Fernand

Nathan, a wallpaper and carpet designer, or the hand-weaver Hélène Henry. This is despite the fact that some, we know, has a sustained impact on the French industry. Lucie Renaudot, for example, produced furnishings for Paul-Alfred Dumas from 1919–1939 and Michael Dubost was head designer at Maison Ducharne, whose studio/school was run along Martine lines from 1922. Edouard Benedictus developed rayon fabrics for Brunet et Meunié. Information on many designers in pre-1940 Europe has been lost because few samples or company records survived. Thus even Stephany's fabrics, made in some quantity by Cornille Frères and acclaimed at the Art Deco exhibition, are now rare.

The direct influence of many of the avant-garde French designers was to wane in the shrinking luxury furnishings market of the late 1920s and 1930s except in America. There throughout the 1920s and 30s, French fabrics could be obtained through leading stores such as B. Altman, Wannamaker, Stern Bros and A. Constable in New York and Marshall Field and Carson Pirie Scott in Chicago, or purchased directly from the Bianchini-Ferrier and Ducharne branches in New York from 1923.

That the American silk manufacturers, Cheney Brothers, felt compelled to keep up with the French is indicated by their maintenance of a studio in France during the 1920s, run by Henry Creange, and their use of Kees van Dongen illustrations, Marie Laurençin watercolours, and Maume Jean Frères stained glass both in their advertisements and as a source of designs. In 1925 the firm moved to a new building in New York and commissioned wrought iron entrances and window decorations from the French designer, Edgar Brandt. Four years later Brandt's work inspired a series of fabrics designed for automobile interiors.

Charles Cheney had no doubts about the importance of French design to the Americans. Speaking in Chicago in 1925 he made reference to an address made in Paris three weeks previously and related that he: "*had to tell the people in Paris that the American silk industry needed their help, that we were in a certain measure dependent upon them for art, for guidance in the creation of our products on the one hand as we were upon Japan as the source of our raw material on the other.....*" The extent of this dependence is further demonstrated by the presence of Bianchini-Ferrier and André Mare fabrics in the Cheney storeroom.

American designers were perhaps not in total agreement with this typical manufacturer's point of view, but when the American furniture designer and architect Paul Frankl conceded in *New Dimensions* in 1928 that, "*there may be sometimes a good reason for copying period art*", his admonition that, "*there never is any excuse for the American creative mind to copy today's European art*", still expressed a minority view.

The English avant-garde designers were more united, condemning out of hand both traditional and 'French-modern' designs. Among DIA members, the painter and textile designer Minnie McLeish was one of the most outspoken critics of the Art Deco style. Unfortunately this tarnished by association most of Britain's mass-produced furnishings as well as many original designs from the fabric ranges of the CPA, F.W. Grafton, Donald Brothers, Warner & Sons Ltd, Morton Sundour, Tootal Broadhurst & Lee and the wallpaper ranges from Sanderson's. Alone among the firms to receive consistent praise from the DIA was Foxton's, producing designs by Constance Irvine, Gregory Brown, Percy Bilkie and Minnie McLeish herself.

The gradual fall in furnishings exports which accompanied the economic difficulties encountered by British industry did not encourage expenditure on artist-designed textiles and wallpapers, nor did interior decoration firms or major shops support modern design to the extent that the French did. Instead, small workshops were being set up in the decade

after the War such as that of Phyllis Barron and Dorothy Larcher, who had been hand-block printing since 1918 and the early 1920s respectively and they were joined by Enid Marx in 1925. The same year Mrs Eric Kennington established a similar studio called Footprints initially to print designs by the artist Paul Nash, but soon it started issuing its own designs. These included many by Joyce Clissold, who eventually took over the management of Footprints and its London shops in the early 1930s.

The 1920s interest in unusual, exotic or expensive wood and stone is reflected in this rayon and cotton damask, called 'Marble'. Designed by Bertrand Whittaker at Warner's in 1923, it was called 'frankly modern & original' when shown at the Art Deco exhibition and in 1926 was used to clad the foyer walls of Claridges in London.

Together with a wide range of other crafts, hand-made textiles had a good number of outlets in London alone between the Wars, among them the Three Shields, opened in 1922 and the Little Gallery and the New Handworkers Gallery, both opened in 1928. There was no shortage of active designer/makers in Britain in the 1920s, but the concept of designing for industry – particularly an ailing one – clearly was not appealing. Added to this was the association throughout these two decades of modern design with reactionary politics – an association which was confirmed by the similarity between the modern French designs and the Russian 'revoluntionary' textiles seen at the Art Deco exhibition. This was not, of course, entirely appropriate to the enormous capitalist enterprise represented by the UK's furnishings mass-producers whose sources for designs was rather to be found among the professional freelance studios. Many of these, like the Giraud, Libert, Hayward and Silver studios, had been founded in the 19th century and maintained by two or three generations of the same family. These could equally be German, French, Belgian, or English, although

the French, as we have seen, far outnumbered the others.

The studios and many professional freelance designers made it their practice to supply what was required by the customer (i.e. manufacturer and occasionally, department store) and thus differed from the artist/designer-run workshops and store-studios. The still dictatorial hand of the manufacturer can be clearly seen in an entry in the Silver Studio day book for October 22nd, 1929 with reference to the Parisian block printing firm F. Vanoutryve, who had *"no use for moderns at all"*, an attitude equally held by the majority of furnishing firms in Europe, America and England well into the 1920s.

The result of these various factors was a rather confusing array of British furnishings.

These included mass-produced designs with the chequerboard, rose-baskets and flattened, outlined flower motifs appropriated by the French, as well as orientalized designs with black grounds, plain woven and decorative printed stripes. All manner of 'folk' and traditional designs were both hand-made and mass produced. Of the latter, the Jacobean-type drawn from 16th and 17th century embroideries and prints were the most common and the least in sympathy with the modern style.

The widespread use of traditional

'Elizabethan' woodblock and print first cut by Phyllis Barron in 1925 for furnishing materials commissioned by the Duke of Westminster on the occasion of his daughter's coming-out dance.

designs was, as already noted, continued everywhere, but only the French among the Europeans seemed able to do so guiltlessly for they had the advantage of being able to lay claim to the major furnishings styles from the late 17th to the mid-19th century. The coincidence of a new style and a revival, both taken from the same source material, had several advantages. Both traditional and modern versions of the Louis XV and XVI designs (particularly the toile style) appealed to post-war French patriotism; they were the most fashionable, each in their own sphere; and they gave a sense of consistency which was difficult to find among national styles elsewhere.

By contrast, the inconsistency of

British design lay at the heart of much criticism levelled at it. Even the so-called French style textiles and wallpapers mass-produced in the UK could be distinguished from their counterparts both by colour palette and style, being warmer in tone and more pictorial or three-dimensional in execution. This, however, did not prevent Basil Ionides in *Architectural Review*, April 1926 from summarizing the sentiments of his contemporaries with the observation that: *"It seems that one has yet to find a deliberate tendency of design in fabrics in fabrics in England, as one finds in France."*

The Americans produced an equally diverse range of furnishings but were less troubled by nationalistic dogma which expected otherwise. Among the several reasons for this must be counted their traditional reliance on Europe for design leadership and the continuous influx of immigrants – many of whom entered the furnishings industry. Furthermore, however effectively the French dominated 'style' in the 1920s, it was in America that the real growth in production was occurring and the success of the new textile firms setting up in the American South made a critical analysis of design seem unnecessary. Original designs for furnishings continued to be provided by the designers brought to prominence by the *Women's Wear Daily* competi-

tions of the previous decade. Modern styles, designed in Europe and America, were also obtainable between c.1925 and 1930 from Schumacher, Contempora Inc., Johnson & Faulkner, J.H. Thorpe & Co., Lenhman-Connor, Inc., The Stead & Miller Co., the Californian store Barker Bros and established sources such as Marshall & Field and Cheney. The latter's advertising campaign, unusual for a manufacturer in the early 1920s, enhanced the company's already considerable reputation and pointed to an area in which the US was to take an early lead – marketing. Cheney may well also be responsible for the first seasonal colour prediction service, which they introduced in 1925. (The British Colour Council was not formed until 1930.)

Among the English manufacturers well established in America were Morton Sundour, A.H. Lee (who carried Fortuny fabrics) and, with Schumacher as their agents, Fox-

The traditional design of the wallpapers by Mauny, 1920 (top), and the modern interpretation by René Gabriel for Papiers Peint de France, 1919 (below), are both taken from the same type of source material. The French obtained success with both types of design, which further enhanced their leadership in 1920s furnishings styles.

ton's. A form of the Jacobean style was imported from UK manufacturers and designers and achieved some success due to its use with Spanish-style architecture popularized by the Pan-Pacific exhibition in San Francisco in 1915. It never achieved as widespread a use as in Britain, where it was associated with the many new suburbs and garden cities being built throughout the inter-war years in late 16th-century vernacular style.

That the Viennese, as well as the British, contributed to the designs widely circulated in America should, by now, be anticipated. The short-lived Weiner Werkstätte branch, opened in New York by Joseph Urban in 1922, although financially unsuccessful introduced many New York furnishings firms to the style just as Manhatten was experiencing an apartment-building boom. Many of the furnishings produced to accompany the cane or wicker furniture, popularized by the vogue for 'garden rooms' which began with such apartments, carried lightly drawn leaf, petal and vine motifs (characteristic of Viennese design) as an alternative to geometric or Cubist patterns.

Across America similar furniture attracted similar fabrics and wallpapers so that up to World War II and even beyond, the association of wicker or garden furniture with simply drawn motifs – particularly palm leaves and stylized tulips – remained

constant. Although America's designs and style lobbyists supported an indigenous style throughout the 1920s, as late as 1930, Helen Churchill Candee was not ashamed to admit that, *"the most beautiful and interesting of all new decorative printed textiles are those composed in Europe, with special emphasis on Paris and Vienna."*

In the second half of the 1920s the leadership from Paris was threatened by a number of developments. Just as the popularization of the Art Nouveau style through the 1900 International Exhibition signalled that the avant-garde would shortly move on, the success of the 1925 Paris exhibition had a similar effect on the style it made so widely known.

An American furnishing fabric of c.1928, from the Ericson & Weiss studio.

Indeed, the manufacturers' enthusiastic reception of Art Deco was equally matched by the avant-garde critics' reservations, for the *"ominous Paris Exhibition of 1925"* was *"held responsible for the introduction of bad Modernism into the trade"* and, *"spoiled the market for serious modern work."* From his vantage point of 1937, Nikolaus Pevsner in *An Enquiry into Industrial Art in England* thus summarized the new attitude which was to ensure that Art Deco, as a furnishing style, would eventually be replaced by a simpler, more restrained approach – although not before the rise in popularity of the Cubist designs.

These Cubist designs bore only slight relationship to the fine arts movement which had first been formulated in Paris before World War I. Together they nevertheless shared a debt to African art, reaffirmed by the Exposition Nationale Coloniale de Marseille in 1922. In common they also employed overlapping and juxtaposed planes, to be found in a preliminary stage in the modern toile designs from c.1919–26, such as those of Dufy, Drésa, Robert Mahais in France, Marion Dorn in England and later Ruth Reeves in America. The pictorial element of such designs only gradually became abstracted, as the impact of developments in architecture, furniture design and the fine arts were brought to bear.

'Manhattan', by Ruth Reeves, c.1928. One of a series of designs commissioned by the New York firm, W. & J. Sloane, it was designed for wall hangings or curtains.

The French were, by virtue of their greater number of participating designers, still supplying and influencing a good proportion of the American and English manufacturers into the late 1920s. They had among them many who were acknowledged as leaders in the new geometric style – such as Sonia Delaunay, whose work was popularized through her friendships with leading French

actresses; and Paul Rodier, who added woven and embroidered net furnishing fabrics to his already highly regarded range of dress fabrics in c.1927.

But leadership was also to be found elsewhere, such as in the Soviet 'constructivist' textiles of the early 1920s by designers such as Varvara Stepanova and Liuboc Popova and the propoganda patterns of c.1927–34 by S. Burylin, L. Silich and others. That these had a continued impact in the UK is certain, for in the first five months of 1933 alone, 80,000 square

A c.1924 fabric design by Varvara Stepanova, an artist regarded as one of the 'pioneers of Soviet textile art'.

yards of Russian printed linen was imported for use in the British domestic market.

While the long-established trade of machine-printed batik-style cloths to West Africa continued in England, Germany, Switzerland and Holland, the revival of abstracted hand-waxed batiks, particularly in America, England and Scotland, emphasized the 'cracked' line or 'droplet' characteristic of the technique. This style was quickly taken up by a number of English manufacturers such as Foxton's, Grafton's and other firms within the CPA, lasting for nearly a decade after the end of World War I.

The American campaign for museum-inspired design followed its emphasis on native North and South American collections with a more global approach. This resulted in, for example, the introduction of mass-produced 'Congo' cloth (inspired by embroidered raffia cloth made by the Bushongo) to coincide with an exhibition of Bantu artifacts at the Brooklyn Institute Museum in 1923. (North African textiles were in fact to attain a unique status in the inter-war years and by the 1930s were, for examples, used to cover Alvar Aalto chairs.) All of these types of textiles remained overshadowed by the mass-produced European-style furnishings until 1926–27, after which they existed side by side or combined with the Art Deco motifs for a further

A French 'modernist' textile design by M.P. Verneuil, 1927. Jagged-edged patterns, particularly in these colours, were often referred to as 'Jazz' designs.

three to four years.

By c.1924 the term Modernist was widely applied to furnishings showing any of these tendencies, although the results varied widely. The French were unable to lay claim to this movement as clearly as they had to Art Deco, despite the importance of the 'pattern books' containing pouchoir-printed Cubist design ideas published between 1924 and 1930 by the French furnishings designers Seguy, Benedictus and Georges Valmier. This was in part due to the very success they obtained at the 1925 Paris exhibition. Both the British and Americans were spurred on by the style-lobbyists' approval of French design as seen at the exhibition (or seen in New York where a

number of exhibition pieces were shortly afterwards on display) resulting in an adoption of the style, certainly, but more significantly, the tactics.

Here the presence of many new magazines is important. Directed at the average consumer, with titles such as *Ideal Home* in England and *House and Garden* (from 1915) in America, these magazines began

'It', a printed silk by Ruzzie Green for Stehli Silk Co., New York, 1928. 'It' here refers to sex-appeal, best known through Hollywood's promotion of Clara Bow as the 'It Girl'.
Hollywood was instrumental in popularizing modern fashions and interiors throughout the 1920s and 30s.

increasingly to exercise an influence by virtue of the furnishings they chose to illustrate. Further, their advertisement space provided an economical means through which manufacturers could reach the public who were often encouraged to, "*ask your decorator* (meaning paint, paper and fabric retailer) *for*" specific products.

Through advertisements, manufacturers could also exploit the established French device of 'name' designers. For example Tootal Broadhurst & Lee Co. Ltd, an English firm known largely for its fairly conservative floral designs in the mid-1920s was, by mid 1928, advertising colour-fast cretonnes (a coarsely woven printed cotton) by the artists G. Day, A.R. Thomson, Elsie McNaught, John and Lucy Revel, T.C. Dugdale, J.S. Tunnard and others.

Manufacturers of cheap mass-produced and expensive furnishings alike were gradually convinced by the after effects of the Art Deco exhibition that Modernist designs were a financially sound investment and not "*just another of those King Tut things!*" (referring to the fad for designs inspired by the opening of Tutankhamun's tomb in 1922). Indeed the *American Good Furniture Magazine* of May 1928, while recording this remark, also observed that, "*the (modern) vogue itself is too big,*

Initially, Bauhaus textiles were more typically wall hangings, such as 'Black-white-yellow', by Anni Albers, 1926. (detail)

and too sound in its original foundations, to be reserved to the province of a few exclusive decorators. It is, to all appearances, a manifestation of the feeling of today, and the sooner the great public is placed in a position of sharing in this movement, as it so eagerly demands, the sooner the wise developers of drapery materials will cash in on their endeavours."

It has been said that the Wall Street Crash in 1929 and subsequent depression did most to bring Modernism to the general public, prompting as it did, simple interiors with a minimum of furniture. But the natural tendency to seek new styles was as much responsible. Further, Functionalism, as practised in Germany and, under their influence, Scandinavia, had already established itself as the avant-garde movement by the mid-1920s.

The Bauhaus, founded by Walter

Gropius in Weimar in 1919, existed for only 14 years, moving to Dessau in 1925 and again to Berlin in 1932, where it remained in existence for a further year. While its impact on modern architecture and furniture design had considerable influence, the textiles had a more muted effect, particularly in the Weimar period when wall-hangings influenced by geometric, abstract trends in painting predominated. In Dessau, the weaving workshop continued to be run by Georg Muche with Gunta Stölzl and Anni Albers newly responsible for the technical training (Stölzl taking Muche's place in 1926/27). Together they came to the conclusion that the future lay in industrial design and thereafter wove thousands of samples for mass-produced textiles, obtaining a wide range of effects by exploitation of both Jacquard and dobby looms and experimentation with new fibres.

The emphasis on the physical structure of the cloth focussed attention on weave, colour and texture – a legacy which was passed only indirectly to other European countries through their export and more directly to Scandinavia, particularly Finland and Sweden, whose furniture designers were the most receptive to Bauhaus ideas in the years just prior to 1930.

Initially, Scandinavian textiles had little impact on mass-produced fabrics. They had few weaving industries and thus their craft tradition retained a significant role in the post-war years. As the 1930s progressed, however, designers such as Elsa Gullberry in Stockholm began to work more closely with industry – concentrated in Northern Sweden. More typical was Sweden's Märta Måås-Fjetterstrom, who produced flat-woven rugs and wall hangings inspired both by the region's traditional abstracted motifs and Middle Eastern patterns. Måås-Fjetterstrom's workshop has been described as Sweden's most significant producer of woven textiles well into the 20th century, but even when cloth lengths were introduced they continued to be woven by hand.

In Finland, it is the educator and architect Arthur Brummer who is credited with raising a generation of textile, furniture and glass craftsmen/designers (through a course similar to that of the Bauhaus), thus contributing enormously to the international prominence Finland enjoyed in post-World War II industrial arts. Finnish hand-woven cloths typically relied on traditional motifs or the small-scale 'birds-eye', 'M's and O's' or other simple woven structures derived from peasant weaves, which were produced – typically of Scandinavia as a whole – in workshop/studios such as Greta Skogster-Lehtinen's, or under the ageis of progressive stores such as Stockman's in Helsinki. There the weaver Greta Nordlin-Sittnikow had charge of an entire floor devoted to modern crafts. Stockholm had Svenskt Tenn — which from 1934 employed the Viennese architect Josef Frank to design furniture and printed textiles – and Nordiska Kompaniet (NK) with its own textile design workshop.

The importance of the Scandinavian textile craft tradition is its longevity, of which Skogster's maintenance of a studio from 1921 to 1975 and Astrid Sampe's 35 year period as head of Nordiska Kompaniet's textile workshop from 1937 are not isolated examples. This continuous tradition, consolidated by 1939 into the furniture and interior style internationally known as Scandinavian Modern allowed Scandinavian textiles an unbroken reign of influence from the mid-1930s to today.

Although the production of mass-produced modern furniture for working class houses had been the goal of Austrian, German and other governments since the 1920s, it was Scandinavian design which achieved an expression of humanistic, Functionalist philosophy which, in the words of Penny Sparke in *Furniture*: *"embraced tradition, craft skills and natural materials, but.....also stood for a highly refined, democratic belief that simple products should be made*

available to everybody, and that craftsmanship need not necessarily be exclusive."

While their printed fabrics were to have only limited impact in the 1930s, it was the conjunction of Scandinavian woven textiles with their furniture that proved significant. More often than not they were simply designed for a specific piece of furniture, as exemplified by Greta Skogster-Lehtinen's fabric woven to allow precisely enough give to adapt to the contours of Lisa Johansson-Pape's 1935 chair, now in the Helsinki crafts museum.

The Scandinavian recognition of the importance of the relationship between fabric and furniture is nowhere better illustrated than by the example of Borge Morgenson's 1945 sofa, which did not sell until 1963 when fabric from a prototype by the Danish weaver Lis Ahlmann was developed for use with it. Although the introduction of mass-produced, metal-framed furniture was accompanied by the exploration of leather, canvas and cane for seating, it was the Scandinavian's choice of woven upholstery for their functional wooden furniture which was to influence a wide range of domestic furniture of the mid-1930s to mid-1960s and contract seating in Europe and America beyond that.

In the 1930s this influence was first felt in Britain – a somewhat surprising fact, since the furniture which accompanied it initially received a somewhat lukewarm reception. This can in part be explained by the parallel developments occurring in Britain's textile industry which had, in certain sectors, never moved away from their use of simple weaves, and by the work of a handful of influential weavers. Astrid Sampe, who together with Barbro Nisson was one of the most emminent Swedish textile designers, trained at the Royal College of Art in London early in the 1930s. She later provided designs for Donald Bros. of Dundee, a firm which, with a handful of others, led the British trend towards simply textured or patterned woven cloths in the 1930s. The English handweaver Ethel Mairet visited Scandinavia on several occasions and introduced Finnish-type weaves into her workshop. Finnish textiles also influenced Marianne Straub, particularly her work for Helios, a firm established in 1936 to produce well designed medium priced fabrics in Bolton, England.

Less surprising is the influence of

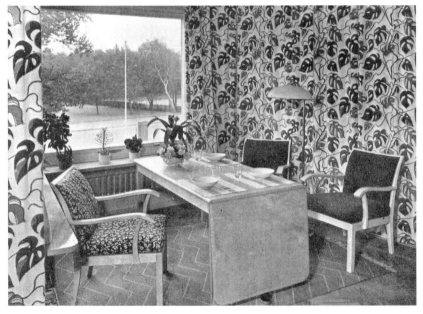

Swedish dining alcove with fabrics by Elsa Gullberg, c.1939. The two chairs covered with a simply woven fabric are most typical of the Scandinavian choice of upholstery.

Scandinavian textiles on late 1930s America, for the principles of Functionalism had been widely applied by the new breed of professional design consultants throughout the decade to consumer goods and interiors. The result, though, was often a rather stylized 'streamline' or 'moderne' form of applied decoration as typified by the treatment of walls with raised metal horizontal or vertical strips which could be imitated by the use of Lincrusta.

While the coincidence of the Bauhaus exhibition in Paris and the international exhibition in Stockholm in 1930 confirmed Functionalism as the approach which was to dominate theories on 'Good Design' for the next three decades; most consumer products followed the American trend towards styling. Certainly the third International Exhibition of Contemporary Industrial Arts (an American Federation of Arts-backed display of decorative metal-work and cotton textiles shown in Boston, NY, Chicago and Cleveland in 1930–31) demonstrated that pattern, albeit abstracted, was still the primary concern for both hand and mass-produced furnishing textiles. Nevertheless, early signs of the separate paths which lay ahead for prints and weaves, by which woven textiles were to virtually abandon the use of figurative motifs, were already discernible. Among the fab-

Fabrics from the 1930-31 International Exhibition of Contemporary Industrial Arts. Clockwise from top left: Hand weaves by Hélène Henry (France), and W.A. Hablik (Germany), and block prints by the Frankfurt Art School (made by the Deutsche Werkstätten Textilgesellschaft) and Marion Dorn (England).

rics on display, the Czechoslovakian, German, French, Dutch, Swedish and Swiss woven cloths were mainly stripes followed by plaids, textural weaves and compositions of squares, triangles, rectangles and circles.

Foremost among the designers of these were the French handweaver Helène Henry, the Germans Anny

May, W.A. Hablik and the teams at the Loheland Werkstätten and Stuttgart's Webercei Pausa, the French designer Elise Djo-Bourgeois (whose woven designs were represented by the Dutch firm Metz and Company), the Swiss hand-weaver Clara Woerner, and Bridgit Lindstrom, Marta Gahn and the Nordiska Kompaniet team in Sweden. Of these only the May, Loheland and Nordiska Kompaniet fabrics were all power-woven – in fact, the exhibition contained far more hand-made than mass-produced textiles. Only Americans with machine-printed cretonnes accounting for over half of their display, showed the commitment suggested by the title of the exhibition, with designs by Henriette Reiss, Donald Deskey and Dorothy Bird Trout as well as several German and English designers. Of the British section, where one would expect to find the still considerable British industry well-represented, two thirds was taken up with hand-block prints by Phyllis Baron, Marion Dorn, Dorothy Larcher, Elspeth Ann Little and Doris Gregg and Joyce Clissold of Footprints, and hand-woven lengths by Ethel Mairet as well as Minnie McLeish, the latter from the Orissa and Bihar cottage industries in India. The Germans showed that they had gone furthest towards the integration of 'art' with industry in the area of woven curtain and upholstery

material, with just over half of their woven fabrics machine made.

The exhibition gives, in microcosm, a fair summary of the years remaining before the outbreak of the Second World War: the Americans with hardly any craft tradition but increasing confidence in their industry; the Scandinavians and English, with small and large industries

'Morden', a Warner's roller-printing design purchased from Eva or Hans Aufseeser (Tisdell) in 1938. The use of light, whimsical lines, typical of middle European design, became more international with the dispersal of such continental designers to the UK and America.

'Bramhill', a block-printed, 'neo-baroque' chintz designed by Alice Sanders-Erskine in New York, 1937. Columns and swags were also particularly popular in the UK in this year, as a result of their association with the Coronation of George VI.

respectively, but both equally influenced by their craftsmen/designers; and the Germans, with the most forward-looking firms, designers and studios, of which the Bauhaus was but one.

The German domination of the exhibition – with 15 firms and studios represented by 68 entries – gives some indication of the loss which was to result from the disruption of design activity in Germany from the mid-1930s to the early 50s. The political upheaval in central Europe and consequent emigration of many architects, designers and artists, greatly accelerated the transference of Functionalist theories of

design to America and England. The major contribution to design in America came from furniture designers and architects. Only Anni Albers, a Bauhaus instructor and freelance designer in Dessau and Berlin, exercised sustained influence on American woven fabrics from 1933 to today. In England the reverse occurred, with furnishings and fashion thereafter indebted to many central European designers.

Among those who moved to England and contributed to the internationalization of design in the late 1930s and post-war years were Mea Angerer and Jacqueline Groag, both trained by Josef Hoffman in Vienna. There was also Margaret Leichner, an ex-student of the Bauhaus, and Hans (Aufseeser) Tisdall, son of an eminent German designer. The industry also benefitted by the arrival of men such as Felix Lowenstein, who left the Pausa Weberei in 1936 to manage Helios.

Meanwhile, the depression was having a detrimental effect on the French, who were no longer visited by Americans (North and South) in quantities substantial enough to support their luxury trades, save the haute couture and fashion fabrics industry. Tariff barriers erected by both the Americans and English served not only to encourage their indigenous industries, but restricted the flow of French designs into either

country. In England, where the institution of tariffs in November 1931 coincided almost precisely with the introduction of hand-screen printing, the result was a serge of support for modern design. In America, the response was to create a luxury style of their own.

The history of the development of interior decorating is a digression too extensive to take here, but by the 1930s the ranks of the established American decorators Elsie de Wolfe (America's first woman decorator), Nancy McCelland (whose *Historic Wall-Papers from their Inception to the Introduction of Machinery*, 1924, is still an important work), Ruby Ross Wood (who 'ghosted' de Wolfe's book *The House in Good Taste*), Eleanor McMillan Brown and Dorothy Draper had been joined by many others. By the last half of the 1930s, "*a growing rebellion against the high cost and stylistic demands of Streamlined Moderne had led to another decorating style – Eclectism – that continues up to today.*" In *Sixty years of Interior Design: The world of McMillan* Erica Brown continues, pinpointing a development which was a boon to manufacturers of wallpaper and chintz:

"*Modernism in America was essentially the vernacular of architects. Decorators, who were now proliferating and being taken seriously as professionals, throughout the decade favored a much more romantic look, one that had its roots in tradition. The Neo-classical style continued, but it was joined by Neo-baroque and Directoire modern.*"

The extensive use of Neo-baroque by Hollywood film makers ensured its transference to Europe. England, in particular, made good use of the style, although never adopting colours as brilliant as those associated with Dorothy Draper. Swathes of curtain fabric were re-introduced – often sheer, in acknowledgement of the modern concern for ample sunlight within rooms. Murals, *trompe l'oiel* effects and surrealistic accessories, too, were part of a determindly light-hearted appearance in interiors, exemplified in England by the work of H.G. Hayes Marshall.

As elsewhere, the English gained many more interior decorators as a result of the depression. John Cornforth documents those who ensured the survival of the English country house style, and with it the floral chintz, which has been the mainstay of many English firms since then. Foremost among these were Lady Colefax, who was joined by Peggy Ward in 1933 and John Fowler in 1938, perfecting among them the 18th-century-style interior that remains the hallmark of Colefax & Fowler. The Modernists were also well represented in England. Betty Joel, Syrie Maughm, Serge Chermayeff and others provided work for the small furnishings firms and supported the avant-garde ranges from established companies. British ocean liners from the mid 1930s also provided a forum for modern British design. In doing so, however, they were a decade behind the French, whose Ile-de-France of 1927 had contained interiors by Martine, Jean-Michael Frank and others.

The late arrival of enthusiasm for modern design did nothing to temper the commitment shown by British wallpaper and textile designers and manufacturers. Although in some respects the lack of a well established modern furniture style slowed their progress, the continued popularity of the mass-produced standardized dining suite and upholstered three-piece suite (two chairs and a sofa) meant that aside from varying the shape achieved by padding the wooden sofa and chair carcases, the major source of individuality was the fabric itself. Further, while American consumers had a plethora of products, mass-produced to designs by their growing numbers of industrial designers, the British buyer had little but new furnishings with which to up-date an interior.

Throughout the 1930s woven fabrics remained the principle furnishing cloths – hard-wearing moquettes (with cut and un-cut loops) for low to

middle priced furniture and finer quality cloths with more modern designs for higher priced pieces – silk damasks were by now the province of the very wealthy. As the furniture makers Parker Knoll, Ercol and Gordon Russell introduced new furniture forms in the 1930s, they also sponsored the use of modern textiles, many of which were basic forms of weaves raised to cult status through skillful redesigning. Established firms such as Donald Brothers in Scotland and Old Bleach Linen Company Ltd in Northern Ireland (both of which also produced modern printed fabrics) were joined in this by new enterprises such as the Rural Industries Bureau. Its scheme to improve Welsh trade by the introduction of a peripatetic designer employed, from 1932 to early 1934: Minnie McLeish, the Norwegian hand-weaver Gerd Bergenson and Margery Kendon, and from 1934–6, Marianne Straub. The Welsh experiment demonstrated conclusively that good design could save an ailing industry and the power-woven tweeds – particularly those by Straub – continued to be produced well into the 1960s, during which time they were used on furniture by Gordon Russell, HK Furniture, Marcel Breuer and F.R.S. Yorke, E. Maxwell Fry and Jack Howe, and Ernest Race.

The interest in such fabrics extended to British designed, Indian hand-woven fabrics made available in England throughout the 1930s by E.C. Ryland (designed by Minnie McLeish) and from c.1935 by Ernest Race – better known for his post-war cast aluminium and steel rod furniture. Such interest also ensured the popularity of muted stripes, strié and gingham patterns in printed fabrics and wallpapers.

More freely patterned modern furnishings were also provided by Turnbull & Stockdale, Allan Walton (established 1933), Edinburgh Weavers (established in 1928 as an avant-garde subsidary of Morton Sundour), Warner's, Sanderson's (wall-

'Aircraft', 1936, by Marion Dorn, hand-screen printed by Old Bleach Linen. It was used extensively in the Orient liner Orcades, *launched in 1937.*

papers and textiles) and John Line (wallpapers) as well as Donald Brothers and Old Bleach Linen. These companies were also responsible for the furnishings provided by designers with their own firms (such as Marion Dorn and Eileen Hunter) or the handful of shops promoting good design. The most influential of these were Heal & Sons, Fortnum & Mason, Dunn's of Bromley, Storey's, P.E. Gane's of Bristol and Gordon Russell Ltd. The concern of the latter that their London premises was becoming known as a fabric rather than a furniture shop confirms the increasingly prominent role modern furnishing manufacturers played during the 1930s.

Throughout the decade surveys in England echoed those in America which indicated that 80 percent of the public preferred traditional design. There is little doubt, however, that the efforts of organizations such as the DIA and the SIA combined with persistent propaganda (in the form of exhibitions and articles in *Architectural Review, Decoration* and other journals) did much to increase public awareness and their choice of modern wallpaper and textile designs.

By 1939, when Hayes Marshall wrote *British Textile Designers Today*, he was able to list 239 designers and record that in his experience as head of the Fortnum & Mason fur-

1930s furnishing fabrics by Donald Brothers. The second from left is 'Coopersall', a hand-screen print designed by Eva Crofts and exhibited at the 1937 Paris International Exhibition. On the right is a stencil and spray-gun printed fabric.

nishing department: *"the only complaint I have heard in recent years is that there are too many designers."* And his list excludes the many artists providing designs for Allan Walton, Edinburgh Weavers and John Line.

The presence among British furnishings of so many that were artist-designed lent credibility to the industry as a whole – just as it had in France in the 1920s. As the American industrial designer Norman Bel Geddes put it in *Horizon*, 1932: "the *artist's contribution touches upon that most important of all phases entering into selling, the psychological. He appeals to the consumer's vanity and plays upon his imagination."*

However, it was the work of the staff-designers (also not mentioned by Hayes Marshall) who, through their selection, interpretation and promotion of designs, led the way. In particular, Alistair Morton at Edinburgh Weavers, Alec Hunter at Warner's, Allan Walton with his own firm and Marianne Straub at Helios brought about a synthesis of continental, British and American design.

The result was a moderate style which represented the mood of the inter-war years. That many of the wallpaper and fabrics carrying modern design were still hand-produced did not matter, what mattered was the legacy of designer-led firms, a legacy which, with the outbreak of war in 1939, was passed to the Americans.

A room designed by Maurice Adams in 1935, the sofa is covered in 'Dunoon', an Edinburgh Weavers fabric designed by Alec Hunter in 1931.

GROWTH AND DECLINE
- INDUSTRIAL CHANGES: 1940 - TODAY

THE type of company which sponsored design innovation in Europe in the first half of the century was either a forward-looking store or a small-scale manufacturer. The Depression or World War II put an end to many store-owned studios and workshops, while the 'craft' sized industries which survived beyond the 1940s – most notably, the leading British manufacturers of the late 1930s – were gradually drawn into much larger corporate structures. The development of the giant textile 'conglomerates', their influence on design and their impact on the economic position of the industry as a whole thus form the background against which all other post-war furnishings were produced.

If the amalgamations before the War were characterized by the formation of the horizontally structured combines, those after the War were of a different nature, being diversified, or vertical, in structure. The first, and still one of the largest of these, was Textron, established in America before the War by Royal Little, who had received his training at Cheney

Eight fabrics designed by Marianne Straub at Warner's 1952–68. (Fourth from the right is 'Munster', 1957, which sold over 500,000 yards through Heal Fabrics Ltd, and which employs the fashionable turquoise blue of the period.)

Brothers. Little may well have taken his lead from the Cheney firm, which owned most of Manchester, the American town in which it was based, until the Depression forced it to sell its land and local businesses. The concept of diversified conglomerates did not immediately replace combines, and between 1944 and '46

one quarter of America's cotton mills were involved in 145 mergers. But among the 117 mergers which occurred in the American textile industry between 1948 and 1954 were a substantial number which represented the extension 'backwards' by sales agents such as J. P. Stevens & Co, to manufacturing units. Such organizations proved more effective in dominating their markets and by 1955 four major American textile companies had increased by over three times their pre-war spinning capacities alone.

In England the same pattern can be found. For example, the large number of printing firms in existence in the 1950s provided a variety of 'base' cloths which cannot be found today – in part due to the requirements of high-speed machinery, but also because so few printing firms now exist. Those that do are owned by Courtauld's (e.g. Standfast), the John Lewis Partnership (Stead McAlpine) or other vertically structured companies. Standardization (or rationalization) was the end result of a decade of massive re-organization

'Groves' by Ben Rose, c.1956. This hand-screen print was available on two types of fiberglass, two weights of linen and cotton random weave.

within the furnishings industry progressed at a rate of 50 to 100 per year. By 1960 the 12 top American companies controlled one-quarter of the market.

Much of the rapid growth experienced by such firms were supported by the expansion of the synthetic fibre industry. In England, Courtauld's and ICI established a dominant rôle in the supply of basic 'commodity' cloths and yarns. This was the result of the 20 year boom following Courtauld's establishment of the world's first million-pound synthetics processing plant in 1951. By this time polyester and nylon, available for use immediately after the War, had been joined by acrylic and modified acrylic fibres. The importance attached to brand-names during the post-war years is evidence of the fortunes which rested on the choice (in America alone) between du Pont's 'Orlon', Chemstrand's 'Acrilan' and Union Carbide & Carbon Corporation's 'Dynel' among the acrylics; or du Pont's 'Dacron', Tennessee Eastman's 'Kodel' and Fibre Industries 'Fortrel' among the polyesters.

The early syntehtics had disadvantages which initially slowed their acceptance in many markets — particularly in medium to high-priced fabrics: they draped poorly, yellowed, attracted dirt and had high non-absorption rates. By the mid-1960s competition had ensured that

of the industry between 1955 and 1965. Once Courtauld's took over Edinburgh Weavers in 1963, for example, the individual character and design leadership expected from the latter could no longer be found, and it was during this period that many of Britain's leading pre-war

firms were closed or bought out.

In the years around 1960, France, Germany and America followed a similar course and everywhere small firms, whether mills, merchants or retailers, were unable to compete against the large-scale companies. In America during this period, mergers

these qualities had been replaced by advantages. Minimum iron, easy stain release, drip dry, permanently shrunk or pleated fabrics are now taken for granted.

Throughout the whole of the 1950s and 60s, the chemical/fibre companies provided America and Europe with an optimism which pervaded the whole of the furnishings industry. In this atmosphere the *new* designer-led firms prospered, particularly in America, where earlier standardization left gaps for small, specialized firms. Despite the fact that synthetics never replaced cotton as a base for printed furnishing fabrics, the introduction of upholstery employing synthetics by firms such as Knoll International demonstrated that the new fibres, where they were seen to serve a purpose, met with no intrinsic objections. And the synthetics industry was controlling much more than the mood of the industry by c.1965, as the use of acrylics demonstrates. This fibre has yet to be printed on successfully by conventional methods in any quantity, but it has many characteristics which suit it for woven or knitted fabrics. Instead it typically is dyed and textured as it is made. Because many other synthetic yarns are also made in the same way, yarn design and colour selection rests in the hands of the 'ingredient' manufacturer. Consequently the growth in colour prediction services during the last 20 years has been supported principally by the synthetics industry.

Reactive dyes, sold first by ICI in 1956 and subsequently by Ciba, Hoechst and other European firms for use when printing cellulosic fabrics (i.e. cotton and acetate), displaced chrome colours in the cheaper ranges. They were also found to be an effective colourant for polyesters, which had a low affinity for the dyes applied by traditional methods.

Post-war colour trends naturally reflected the introduction and constant improvement of new dyestuffs. The fashion for bright turquoise blue throughout the 1950s was, for example, the result of ICI's introductions of 'Alcian Blue' in 1950. Vat dyes, which have remained in use for top quality furnishing fabrics, were thus used in greater concentrations to equal the brilliance offered by this and other new dyes, such as those which gave the public the deep yellows and bright oranges of the late 1950s and 1960s.

Hand-in-hand with the development of new dyes and fibres, the synthetics manufacturers also promoted knitted upholstery fabrics, which were seen as a natural end-use for their product. Double-jersey knitting was introduced into Britain by the Hungarian refugees of the mid-1950s and spread quickly to America and Europe. Its application to free-form funiture in the 1960s, although a limited phenomenon in itself, contributed to the demise of woven fabrics as an upholstery cloth. Weaves only remained an important part of elitist interiors, for which the term, 'international style' was coined, meaning the functional, rational approach to the use of materials in furniture and architecture, and one which was thought to be fairly universal in its application. In textiles and wallpaper, an international style also developed in the 1960s which owed a great deal to the conglomer-

'Tree Section', a screen print by Shirley Conran, 1957, is typical of many furnishings of the 1950s in its use of a cross-section of an organic or mineral substance.

ates — for they themselves were international. America's Burlington Industries Inc., for example – the world's largest textile organization in the mid-1960s – had, aside from its holdings in the United States, just over 100 mills in Europe, South America, Africa and Canada.

The War had focused attention on new material and new uses for known materials, and the enthusiasm with which these were greeted ensured exploration, not only into the extension and improvement of synthetic fibres and dyes, but in many other areas which affected the use, appearance and structure of wallpapers and textiles. One of the most straightforward effects was the adoption of scientific and technological images, among them plant forms in section, patterns depicting molecular structure and movement, and shapes enlarged from microscopic or photographic studies. Some, such as Tibor Reich's 'Foxteur' and the Festival of Britain's crystalline – structure patterns, were actually promoted on the basis of their 'scientific' derivation. Typography and calligraphy were naturally aligned to this interest in the visual language of science and engineering, and the use of typefaces in designs – particularly those of c.1953 by Bernard Rudofsky for Schiffer Prints Division, Mil-Art Company, Inc. in America – prepared the ground for the 1960s' interest in

'Bolero', 1968, by Timo Sarpaneva. The manufacturers, Tampella, employed robots in a printing process which was kept a well-guarded secret.

super-graphics.

New surface treatments of all kinds were experimented with for both wallpapers and textiles, whatever the price. Roller prints with metallic ink overprints baked on were introduced in America by Covington Fabrics and, during the early 1950s, the desire for high colour could also be obtained by the chemical treatment 'Day-Glo', making colours luminescent. Weavers had Lurex, developed by Doebeckman (USA) and available around the world by

c.1952.

Further, the 'new' became as important as the 'modern'. Birge, one of America's largest and most well-established wallpaper manufacturers, introduced a new technique for veloured papers in 1951 for which the ability to vary the shade within a motif allowed the traditional nature of the designs to pass without comment.

The 1969 American Institute of Designers' awards show how long-lived was the enthusiasm for new materials and treatments of them. They honoured Dorothy Liebes as a colourist and an innovator with synthetic and man-made fibres, Sewell Sillman for his glass curtain fabric for Jack Lenor Larsen Inc (JLL), Tenneco Laboratories for 'Frontera' (a man-made suede-like material manufactured by Tenneco Advanced Materials Inc), Timo Sarpaneva of Finland for the Ambiente collection (which used robots for a new method of double-sided printing and was distributed by JLL), and a screen-printed wallpaper on aluminium foil by Arline Sumida, made by Stockwell Wallcoverings Inc. Only the award to Gere Kavanaugh for 100 per cent silk, warp-printed fabrics, imported by Isabel Scott Fabrics Corporation, indicates the return to an appreciation of natural fibres and 'native' techniques which was to characterize

the 1970s and 80s. Even so, some war-time developments have remained an important part of light-industrial or commerical interiors.

The war-time need for good rubber substitutes and materials that were waterproof, mothproof, mold and mildewproof, and flameproof, led to the introduction of vinyl-based compounds which brought a flood of new 'plastic fabrics' and wall-coverings onto the market. This was particularly the case in America, where decorators such as Dorothy Draper established their currency.

The high performance of a fabric-backed, resin-coated, heat-embossed wall-covering created a new formula for office interiors and provided safe, durable surfaces for the moveable partitions or screens which became part of open-plan schemes. Wallpapers were thus essentially

A kitchen/dining room depicted in Ideal Home, 1959. *With the exception of the plain curtains, no other fabrics or wallpaper are employed.*

'Magnum', a 1970 Jack Lenor Larsen fabric employing cotton, nylon and vinyl, machine-embroidered onto a mirrored, Mylar polyester-film ground.

restricted to domestic use, and when Britain's Vymura (from ICI Plastics Division) combined poly vinyl chloride (PVC) coating with paper in 1960, and backed up technical innovation with styling by Robin Gregson Brown, established forms of paper wallcovering faced competition even within the home.

In the broader category of plastic fabrics, the vinyl compounds were produced in three basic forms: all-plastic sheeting for upholstery or thinner gauge film for curtains, the coated fabrics, and monofilaments

for weaving such as saran (developed by The Dow Chemical Company from 1937). Like the synthetic fibres sold by the same companies, each had its own brand name and there were over 50 to choose from by the early 1950s.

The lead taken in architecture by American West-coast designers after the War led to an emphasis on indoor-outdoor furniture for which these 'fabrics' were essential. The enduring use of printed shower curtains is all that remains of the once widespread domestic use of resin-

coated upholstery and curtain materials. Their use now occurs mainly in areas where heavy use and high saftey specifications require additional protection.

Parallel developments in moulded and extruded plastics were applied in furniture making. As is typical of the attitute towards synthetic fibres in the 1950s and 60s, plastics were received, not as cheap substitutes as they had been in the 1930s, but as modern expressions of technological prowess. For woven fabrics, already under pressure from knitted upholstery, this further reduced its rôle in many types of furniture production. The ephemeral 1960s cardboard or plastic blow-up furniture on the one hand and the Italian luxury furniture covered with leather, skins or furs on the other, also pushed woven upholstery fabrics into a very expensive, specialist market.

Although the lighter weight of synthetic yarns made sheers more common for offices and public spaces with large expanses of glass, the many new products which made money for the chemical-textile conglomerates often left little room for the cloth designer. It is little wonder that the explosion of 'fibre-arts' coincided with the plastic/fur/fibreglass phase of the 1960s.

Other War developments affected curtain fabrics too. The development of light-weight substitutes, such as magnesium for steel, led to lighter Venetian blinds, which as a result could be utilized for much larger window areas. It gradually became possible to create a modern interior without recourse to any of the traditional forms of wallpaper or textiles. Yet despite this – or perhaps because of it – furnishings became more significant either as humanizing images for otherwise stark interiors or as colour masses manipulated to off-set the neutral tones of concrete and glass. As a result during the peak years of the international style for furniture and architecture (1950–65), many furnishings designers were fêted as celebrities.

The nature of the synthetic fibre industry — product based rather than design based — was gradually recognized by those within it as a limitation, and the marketing which was undertaken to combat the impersonal character of early synthetics, occurred first in America and followed in Europe. It also spread to other types of related textile production. Such marketing capitalized on 'star' designers, particularly in the polyester/cotton sheet markets, which used 'designer' bedlinens in the late 1960s as a means of identifying fashion with their utilitarian product. Fashion also meant fashion-change, or inbuilt obsolescence, an equally important factor given the long life of the higher quality, blended fabrics available from the late 1960s. Recognition of the importance of design was also given enormous support from other quarters: education, journalism and exhibitions.

While exhibitions had already been established as a means of creating and disseminating style leadership, their role broadened in the post-war years to include the larger task of defining good design. This process began with exhibitions such as the 1933 Dorland Hall show in London and the Museum of Modern Art (MOMA) series of 'Good Design' exhibitions in New York, the first of which was held in 1940. Inaugurated by Edgar Kaufmann, Jr, the latter were seen as the centre of a vast public education programme and were shared by museums and galleries across the United States.

The shift to museum-sponsored exhibitions was important. By accepting industrial design into the previously sanctified arena of fine art, such exhibitions encouraged designers, manufacturers and the general public to assess – and generally approve – the products of modern technology. The Walker Art Centre of Minneapolis, Minnesota opened its 'Everyday Art Gallery' in 1945, emphasizing new materials and techniques. Its stated aims were to promote good design in household objects, although this did not neces-

sarily mean inexpensive objects, for among the items selected for a 1953 exhibition were hand-screen prints and wallpapers by Ben Rose, Angelo Testa and Donelda Fazakas and hand-woven fabrics by Marianne Strengell and Evelyn Hill. Nevertheless, alongside these were cloths, power-woven by Edwin Raphael Co. from handwoven prototypes by Marli Ehrman, showing adventurous use of inexpensive yarns: rayon, Dynel, spun saran and metal.

The 1956 MOMA exhibition, 'Textiles USA', marks a turning point in the US. While the 1948 exhibition along similar lines was still anxious to present an industry which could function without the stimulus of foreign inspiration, the 1956 exhibition dared to criticize the industry – a certain sign of its assumed strength. The catalogue essays by Arthur Drexler and Greta Daniel offer not only a perceptive analysis of American textiles – noting the importance of synthetics, of marketing and of more rapid replacement – but they also set out to re-define the criteria by which designs were judged. Drexler points out that,

'Organic Fabrics', 1942, by Antonin Raymond, from a MoMA 'Good Design' exhibition.

"If the craftsman's kind of variety, a virtue because it cannot be suppress-ed, is less in view, it is also true that a new kind of variety is evident. There are simply more kinds of textiles from which to choose than ever be-fore, though it is true that much of this variety is imperceptible to the consumer and is exclusively the by-products of competition for his dol-lar. And mass production seems slowly to become more flexible."

In the light of this, Drexler suggested that,

"'Pure' and 'quality' are misleading terms when applied to just those areas of textile production in which some of the most important indust-rial innovations are at work; synthe-tics, for example."

Through statements such as these, craftwork – long regarded as the area from which leadership would come – was relegated to a separate, if not secondary, status.

The Milan Triennales were re-established after the War and in the 1950s and 1960s became the most important of another type of exhibi-tion – those which gave awards. Even unlikely events such as the California State Fair and Exposition in Sacra-mento gave gold medals that were highly regarded. Success at an inter-nationally recognized exhibition was crutial. The Scandinavians' consis-tent performance in Milan contri-

buted to their influence during the 1950s and early 1960s, an influence which was further spread by exhibitions of Scandinavian-design products such as the 'Design in Scandinavia' tour which took in 21 American and Candian museums between 1954 and 1957. In the 1950s, individual designers – Astrid Sampe from Sweden, Lucienne Day from England, Dorothy Liebes from America, Ilmari Tapiovaara from Finland, Ellen Fricke from Germany – found recognition and work outside their own countries, in part through the accolades they received at such exhibitions.

There were also other forms of awards: those by which peers acknowledged peers, given by the American Institute of Designers, the Royal Society of Arts in England and in Scandinavia, the Lunning prize, given to two designers annually from 1951 to 1972. Competitions also proliferated, and together with exhibition prizes and professional awards, they established a pedigree system which was exploited by manufacturers. In 1945, for example, Katzenback and Warren Inc., were still advertising the wallpaper collection they created for the Miriam Miner Wolff interiors at the New York World's Fair of 1939. L. Anton Maix publicized their 1951 MOMA Good Design awards and credited the designers: Joel Robin-

son, Paul McCobb, Paul Rand, Serge Chermayeff and Elsie Krummeck. From c.1953, Heal Fabrics Limited in London always issued their designs with a brief biography of the designer, invariably including lists of prizes or awards.

If manufacturers used designer names as part of their marketing and promotions, it was entirely with the support of the various professional design organizations which worked so diligently after the War to establish the status and rôle of the designer. In every country, design organizations arranged numerous exhibitions of home furnishings both on a national and a local level in the two decades after the War. The Council of Industrial Design (CoID), formed in England in 1944, staged the 'Britain Can Make It' exhibition of 1946 and the 'Festival of Britain' of 1951. Both channelled attention towards modern, stylistic developments and the former was the first British exhibition to explain to the uninitiated how a designer worked. Supported by Scandinavian design organizations, the international 'H 55' (Halsingborg 1955) exhibition in Sweden was followed by annual 'Scandinavian Design Cavalcades' which rotated among Scandinavian countries. But,

"the design organizations did more than arrange exhibitions, they became prominent advocates for

their field. They encouraged industry to invest in enlightened product development; they lobbied the government to support good design in their export policies; and they educated the general public to be aware of better design and 'more beautiful things for everyday use'."

The efforts here outlined in *Scandinavian Modern Design 1880–1980* were made simultaneously across Europe and America and were important in the development of design in the late 50s and beyond.

In England, organizations such as the SIAD, the CoID and the Cotton Board's 'Colour, Design and Style Centre' (opened in Manchester in 1940) carried out programmes similar to those in Scandinavia. Under the guidance of the industrial designer Misha Black, the SIAD extended its membership and influence and during Alec Hunter's presidency (1956–58) a committee was formed to examine the Society's professional status. The SIAD also organized exhibitions in conjunction with the Style Centre, which had quickly established a reputation for innovative, original methods of presentation and promotion. Jimmy Cleveland Belle, director until 1950, worked assiduously to present cotton manufacturers with exhibitions of British and foreign goods. The exhibitions' content extended to well beyond just

cotton as indicated by the Centre's name, to include furniture, glass, carpets and wallpapers – and Belle's efforts were supported by journals such as *Ambassador*.

Belle's exhibition of Scandinavian textile in the mid-1940s had a seminal influence on British style of the period, as did the 'Origins of Chintz' exhibition organized in the mid-1950s by his successor, Donald Tomlinson, and subsequently enlarged and presented at the Victoria & Albert Museum in London. The latter exhibition marks a turning point after which the English were to market their chintzes with greater confidence and in increasing numbers. The success of the Style Centre – particularly its support of young designers such as Gillian and Colleen

Above: 'Periwinkle' wallpaper, designed by Edward Bawden and produced by John Line, as shown at the Festival of Britain, 1951.

Right: A design by John Aldridge, one of several purchased by Marianne Straub from the first 'Colour, Design and Style Centre' exhibition, 1940.

Farr, Natalie Gibson, Audrey Levy, Howard Carter, Peter McCullock, Pat Albeck and many others, and its ability to promote their work to nearly all of Britain's leading furnishing firms – is reflected in a series of 'Inprint' and 'Design-In' exhibitions between 1964 and 1974. Their spin-off, 'Texprint', started in 1972 and after some years absence, is once again promoting young designers' work.

The Style Centre's success was nevertheless somewhat ironic, for while synthetic fibre and cloth production was on the increase everywhere, cotton spinning and weaving continued its pre-war decline in England, despite efforts which returned production levels in 1951 to those of 1934. The figures are staggering: between July 1956 and July 1957 1½ million spindles stopped; nearly 30,000 looms ceased weaving and for the following five years the same scale of reduction occurred. This was caused in part by the shift of basic yarn and cloth production to India and Japan, which by 1950 were the leading textile exporters. Political events, such as Ghandi's boycott of English cloths in India, contributed to Britain's difficulties and as a result, cotton spinning and weaving in the UK in 1960 was more or less comparable to that of France or West Germany. In 1965 Britain became a net importer of textiles.

Although world-wide consumption of fibres per person is now over five times greater than it was in 1946, by the second half of the 1960s, Europe and America were also using more imported fabrics than their own. The acknowledged need to compete against Asian and Indian low-cost production had concentrated efforts on the improvement of known techniques and the social cost in lost jobs was the price of the higher-speed, higher-volume production made possible during the 1960s. The end result was over-capacity, brought to a head by the oil crisis of 1972/3 and the subsequent recession. ICI alone, in its consequent restructuring, shed over 60 per cent of its synthetic fibre force in Europe. Between 1972 and 1982 employment in the British textile industry fell by a further 65 per cent, yarn and cloth production was halved, and similar figures could be quoted for other countries. Wallpaper manufacture was also affected by the recession, which in England added to the Wallpaper Manufactures' Association problems as the first target of the Monopolies Commission. The WPM was sold to Reed International in 1965 and eight of their factories, including Sanderson's, were closed. Famous trade names such as John Line and Shand Kydd (which had merged with Line in 1958) dis-

appeared and finally Crown Wallpapers was sold to an American firm in 1984. In many cases, it was the co-ordination of wallpapers and screen-printed fabrics which maintained wallpaper sales throughout this period.

Screen-printed furnishing fabrics were, in fact, the only form of furnishings *not* to decline in production throughout the 1970s, partly as a result of the dominant place they had held since the late 1960s, by which time woven fabrics had virtually

Linen curtain material, c.1955, designed by Marianne Strengell. The flexibility of hand-screen printing is here demonstrated by the use of one screen, double printed.

disappeared from the mass-market. The mechanization of screen printing – widespread by the late 1950s – had allowed, for the first time, a combination of low 'start-up' costs with mass-production. (Copper rollers, by contrast, were expensive and required much longer runs to be profitable.) Both flat-bed and roller screen printing retained most of the advantages of hand printing, the most important of which was the fidelity of the end-product image to the original design. Its close relationship to hand printing, which was fairly well established in design colleges by the end of World War II, meant that – again for the first time in printed textile design for mass-production – students could produce their own work in a manner which reasonably approximated mass-production. Further, they could – and still do – economically set up hand-printing workshops of their own, an advantage which even the hand-weaver does not share. Thus the close relationship between the educational and vocational experience was a contributing factor to the dominance of prints which steadily increased after the War. The pre-eminence of many designers in the same period also rested on the combined flexibility and semi mass-production possible with hand screen printing.

The oil crisis did have some side-effects which were beneficial: the higher cost of plastics and oil-based synthetics re-established woven upholstery fabrics and all natural fibres as economically competitive during the 1970s. Increased competition resulted in the transference to the conglomerates of some of the responsibilites originally taken by others. Marketing, for example, broadened into design sponsorship, and many characteristics of today's industry are based on the formula promoted by organizations such as the Style Centre. Greater attention was focused on new, technology, rather than faster old technology, and thus transfer screen printing (for polyester and polyester blends) and computer-aided design became more important. Computers had an even wider effect, for they made increased mail-order and credit card purchasing possible, which in turn created what the Americans call 'specialogues', or in-house catalogues which combine mail-order with style promotion. They also made the checks and controls on inventory more accurate, making large and small firms alike more sensitive to consumer demands. The global nature of the furnishing industry today is supported by computerized information networks which offer some measure of protection against economic changes and trade barriers.

Shifting exchange rates and tarriffs, quotas and other protectionist measures are subjects of great significance to the health of furnishings industries everywhere. In general the Americans have used tarriffs to protect their products, while the Europeans have instituted quotas. Neither, however, have been able to prevent increased importation from developing countries, nor have they been able to control the effects of strong currencies, which generally make exports more difficult. In 1949, for example, the devaluation of the British pound increased exports to America; similarly, the weakness of the dollar against Japanese and European currencies (except the UK and Italy) between 1970 and 1980, increased American exports to these countries. Stylistic influences follow in the wake of these export pattern, and thus the relative weakness of the British pound today is in part responsible for the world-wide demand for English chintzes.

The uneasy economic position of European and American industries is also reflected in the fact that, until very recently, the last 15 to 20 years have witnessed more retrospective exhibitions than those on contemporary design. The trade shows in Chicago, Frankfurt, Paris, Milan, London and other venues took the latter's place, but serve only some of the same functions; certainly, they promote the exchange of designers and design ideas between countries.

'Peony Gardens', 1969, designed by Richard Hanley for Warner/Greeff. This colour-way is still available, having sold over 1 million yards and inspiring numerous variants.

By 1986 weaves had re-established a significant place in contract and domestic furnishings, aided in part by promotions from the IWS. Left to right: 1, Kawashima Textiles (Japan); 2 & 3, IWS and 4, Ad Wever (Germany).

Educating the public, however, has become the remit of design and interior magazines, whether specialized, such as *Domus, World of Interiors*, or *Design*, or general, such as *House & Gardens*. The increasing importance – and proliferation – of design related publications can be linked to the greater use of colour illustrations, which have slowly increased in proportion to black and white reproductions since the 1950s until today. This gradual change has also affected the appearance of many designs, as can be detected in the higher incidence of patterns in black and white (or a single strong colour and white) during the 1950s and early 60s. Today's all-colour publications which utilize higher quality paper allow faithful reproductions of washed, watercolour-like pastel shades. Were this not the case, it is unlikely that they would have recently been so fashionable. Indeed, the renewal of interest in design and its promotion by government and corporate – sponsored organizations and museums has been supported by high quality printing of both magazines and books. Such publications have, of course, further contributed to the internationalization of furnishings which has occurred during the last four decades.

The international nature of wallpapers and textiles can, nevertheless, be divided into two phases: stylistic and philosophical. While throughout the century designs originated in one country have been produced in another, the focus on designers and design education in the first two

decades after the War led to the acknowledged use of, say, a Swedish designer's work by Knoll Associates in America, or an Italian designer's work by Heal Fabrics Limited in England. In addition, the consumer society of the 1950s and 60s and the democratic spirit of design combined to ensure that no one Western country could claim absolute leadership in design, and the result was a fairly homogeneous style. After c. 1970 the individual character of each country's production (or each company's production) began to be re-established, but because so many firms are now international concerns, the full spectrum of design is still

readily available in the western world.

Internationalism is now an attitude rather than a 'look'. The large conglomerates, which have directly and indirectly shaped much of the industry's history in the last four decades, and which have inspired many of the small successful firms of the 1950s and 60s to expand and diversify, have adopted a less hard-edged, cut-throat approach in

the face of economic difficulties. In the Textile Institute's *75th Anniversary Souvenir Publication*, 1985, Reijo Selin, managing director of Finland's Oy Finlayson Ab, summarized the new philosophy: "*Internationalization no longer means just the export or import of physical goods, but involves international co-operation with raw material suppliers and customers as well as industries in the same line of business.*"

The English 'manor house' style, now internationally available. The wallpapers and fabrics are from Colefax & Fowler, London, 1985/6.

'Flower Dance', by Melanie Greaves for Warner's, 1986. Winner of a 'House & Garden award in 1985.

THE DESIGNER DECADES
-DESIGN: 1945-1964

THE course of good design and 'Good Design' from 1945 to 1964 was principally set by two factors: the new post-war consumer society and education. To appreciate why these were to play such an important part in the development of wallpaper and textile design one must begin with the effects of the War itself.

The impact of the Second World War was far more dramatic than that of the First – at least as far as textile and wallpaper manufacturers were concerned. Of all the European countries it was only Sweden which was able to continue an uninterrupted development of its crafts and industry, including the building of houses. As a result of their national isolation it nevertheless became what the art historian Dag Widman described as a time of, *"idyllic retrospection and decorative formalism"*, as evidenced by the lush vegetable forms introduced into Swedish printed textiles by Josef Frank, Gocken Jobs and others.

In Britain, shortages of manpower, restrictions of raw materials and conversion to war-work disrupted the furnishing trades severely – wallpaper manufacture soon ceased and most available stock had run out by 1942. Furnishing textiles continued to be produced in limited amounts for exports although the majority were woven fabrics for home use which conformed to the requirements for black-out cloths. While not necessarily black, they were dark and had a minimum of pattern. Even before 1943, when Enid Marx was appointed to design small-scale four colour weaves for use with the Board of Trade's Utility furniture (controlled by Gordon Russell), the colours in prints and weaves had been severely curtailed.

From among the pre-war trends only the experimentation with new materials continued – out of necessity. In England, Marianne Straub employed cellophane within Helios weaves and commissioned prints on fibreglass cloth, which remained un-rationed throughout the War. In Finland, Dora Jung's paper-thread upholstery fabrics and Greta Skogster-Lehtinen's wall-hangings and wallpapers made with birch bark, typify the Scandinavian's search for substitute materials.

America also gradually began to feel the effect of shortages. By mid 1942, Government restrictions on dyestuffs, design size and fibres had been imposed. While long established firms such as J.H. Thorp and A.H. Lee were still able to secure imported, block-printed fabrics from England by virtue of their ties within the latter country (and in Lee's case, were also able to maintain a stock of Fortuny fabrics), younger firms such as Scalamandre silks (established in 1926) were forced to replace their French and Italian brocades and damasks with similar designs printed locally on raw silk. Throughout the War, America maintained its demand for luxury goods and provided a ready market for traditionally styled furnishings, whether European or American, authentic or "make-do" in manufacture. Cheney Brothers, whose refusal to introduce rayon during the Depression had resulted in serious financial problems, were among the many firms forced to replace some of their natural fibres

with man-made yarns. In Cheney's case the change came too late to save the firm, for within a decade of the end of the War it had been acquired by Greeff Fabrics Inc.

Both the substitution of yarns and the lighter weights of cloth required as a printing base, set precedents for the next decade and beyond. Prior to the War, the provision by W. & J. Sloane (New York) of the same Ruth Reeves 1928 print on a variety of cloths was a novelty in the retail trade. By the end of the 1940s, however, it was not unusual to find new, leading firms, such as Laverne Originals Inc. (founded c. 1938) offering a modern design on two or more cloths, often with matching wallpapers. In 1949, Eric Hand Prints in Los Angeles advertised designs by Richard Haines and Eric Erickson printed on, "*boucle casement or any other fabric.*" This trend developed into the use of sheer and heavy prints for double curtain sets in the late 1950s and 1960s, and later into mass-produced, matching bed-linen and curtains or curtain and upholstery weight fabric, both of which are now widely available.

Matching fabrics and wallpapers were also promoted in America during the War by firms such as S. Schumacher & Co. in New York. Many firms supplied co-ordinated fabrics (normally checks, pin-stripes or broad stripes in colours to match a floral print), although Greeff appears to be the originator of the 'collection' concept, whereby groups of fabrics and wallpapers – not co-ordinated, but based on one theme – were introduced and publicized together. Schumacher (founded 1889) and Greeff (founded 1933) organized their wholesale ranges in much the same way as the designer-led English firms such as Warner & Sons (founded 1870) and Morton Sundour/Edinburgh Weavers (founded 1888/1928) — small avant-garde ranges were combined with high quality, traditionally styled fabrics and wallpapers.

Among the established wholesale firms, Greeff and Schumacher were also two of the first to adopt the 'designer name' approach which had so well served the French in the 1920s and the English in the mid 1930s. Schumacher did so with its range of hand-screen prints and weaves styled by Dorothy Draper and Greeff with designs by John Little (a New York designer active from the 1930s) and Dagmar Wilson. Their introduction of these ranges in 1942 – with the designer's name printed on the selvedge – coincides with increased coverage of furnishings in American magazines. According to *Interiors* of August 1942 and February 1943 the policy was taken because, "*abnormal conditions have delayed salesmen who call on out-of-town interior designers...and they may miss some towns and cities*"..."*The printed page, editorially and through advertisements, is rapidly becoming the salesman's pinch-hitter for the duration.*" Thus was finalized the wholesaler's policy of advertising directly to the buyer — a trend started slowly in the 1920s but resisted by many interior decorators and department stores until the outbreak of World War II.

Without rationed buying, America's furnishings firms found that almost anything would sell. The enforced 'stay-at-home' psychology which directed attention to interior decoration was initially to the advantage of wallpaper manufacturers in particular. They remained bouyant well into 1942, despite the restrictions on pigment colours which eliminated dark backgrounds, brilliant colours, metallic powders and certain shades such as yellow. The only shortage complained of was that of skilled paper-hangers, by which was founded the post-war interest in do-it-yourself decorating.

By the end of the War the situation had altered. A limited number of relatively expensive hand-screen printed papers continued to be produced with new designs, but the copper for rollers on which America still depended for its mass-produced wallpapers (and many of its mass-produced textiles) had been re-

Helios fabrics, 1937–49. The print is by Marianne Mahler, c.1940 and the weave next to it by Otti Berger, 1938. The remainder are by Marianne Straub, with the small geometric patterns showing her knowledge of Scandinavia's 'bird's-eye' weaves.

quisitioned by the Government. New designs were not available until 1947; stylistic changes thus slowed in the mid 1940s.

Throughout the period the so-called 'tropical' patterns introduced in c. 1937 remained popular as a reflection of America's increased interest in its neighbours to the south, and its military activities in the Pacific. But the neo-Baroque (variously called Hollywood Baroque, Baroque modern and birdcage Baroque) was deemed less appropriate as the War progressed. It was relegated principally to use in hotels, restaurants and nightclubs which were frequented by a public who, in the words of an American journalist in 1945, "*don't want to feel functional, they want to feel Grand.*"

All traditional styles came increasingly under attack from European and American 'style-lobbyists' as the War was ending. The neo-Baroque in particular, described by *Interiors* of September 1945 as, "*the loud expression of a suppressed inferiority complex*", was considered unsuitable in the increasingly confident years of the late 1940s. Good Design became the subject of countless exhibitions and publications, most of which had tri-part aims: to educate the public, to educate the manufacturer, and to re-establish export markets. The effect of these was not really to be felt in the mass

A 1940 tropical design, 'Calla Lilies', by Stanley Coventry for Stroheim & Romann, New York.

market until the end of the 1950s, when the individual's purchasing power in Europe reached a level which united them with America in one large Western World consumer society. Meanwhile, someone had to define what Good Design was. To lead the way were the corps of young designers, of whom the most articulate (of furnishings designers) was the American, Angelo Testa.

Testa was a 1945 graduate of the Institute of Design in Chicago, whose teachers and guest lecturers included the ex-Bauhaus directors Walter Gropius, Ludwig Mies van der Rohe, and other Bauhaus men, including the Institute's director, Laszlo Moholy-Nagy. At the Institute (originally and aptly called the New

Bauhaus), Moholy-Nagy further refined the theories of the Bauhaus. Testa was later to comment on these in the catalgoue to his retrospective exhibition held at the University of Illinois in 1983, the year before his death:

"How brazenly so many are revealing their lack of understanding, ignorance, in claiming that after 50 years of white walls, glass boxes and functional design we are now realizing the validity of decorativeness as an idea. The Bauhaus has been blamed for this sterile visual environment that we live in. This is an unforgiveable transgression of truth. The Bauhuas did not condemn or outlaw ornamentation. It did adhere (to) honesty of approach in the use of materials and technology."

Testa's rebuttal of the, *"unfounded and unjustified criticism of the Bauhaus"* was offered in reply to the rejection of Functionalism occurring among today's Post-Modernist architects and furniture makers. But it was Testa, rather than the original Bauhaus members, who first applied and described a rationalized theory for printed textiles and wallpapers (as opposed to weaves). In an article in *Interiors* he attacked the American 'museum to consumer' design movement of the pre-war years because,

"the architect realizes that these designs have no relationship to his space articulations and makes every effort to substitute glass, wood, metal, plastics. Therefore the printed fabric has been out-lawed from the contemporary building and will continue to be ostracized until the situation is remedied." He then offered his solution:

"The textile designer must start with a piece of plain fabric in mind. He must determine what the function of this fabric is and what justification he has for putting a design on it. He needs to experiment with line, form, texture, and colour, keeping in mind the monotony of most prints...and refrain from complete coverage,

'Filo' by Angelo Testa, hand-screen printed on cotton in 1942.

destroying the natural beauty of the textile. Texture should be emphasized where the decorative function of the fabric is minimized, and colour and form where the function is purely decorative."

Although written early in 1948, these remarks both recognized the trends already present in European pre-war furnishings and predicted their progress in Europe and America over the following 10 to 15 years. During this time, texture became so important *"where the decorative function..is minimized"* that this rôle was taken by weaves, leaving prints to provide *"purely decorative"* colour and form. Testa's approach essentially freed prints and wallpapers from many of the restraints of Functionalism or, put another way, acknowledged that decoration *was* the function of most furnishings. Such polemic lent a credibility to prints and wallpapers which previously had only been enjoyed by weaves. This, together with the improvements in screen printing, attracted both established and young designers to the field.

Testa's own furnishings designs between 1942 and 1960 rely largely on lines of irregular width in geometric or 'doodle' patterns. Many were hand-screen printed by his own firm in Chicago and others were similarly produced by Greeff, Forster, Knoll

Associates or Cohn-Hall-Marx, some with matching wallpapers. His designs of 1947 for mass-production (ie roller printing) were said to be the first 'contemporary' American printed textiles and were distributed widely and copied often. Although not available for purchase elsewhere, due to post-war restrictions on imports, illustrations of Testa designs contributed to design developments in Europe, particularly in England, where the term 'contemporary' seems to have been coined by John Line for a collection of wallpapers showing rhythmic use of line and mass, much in sympathy with Testa's approach.

Of course, that there were many other designers and firms in America producing abstract printed textiles and wallpapers during the 1940s and '50s goes without saying. Dan Cooper Inc., Schiffer Prints, Ben Rose Inc., Laverne, Elenhank Designers Inc. and Adler-Schnee were leaders among them, but they were all producing by hand well into the 1950s. Elenhank, founded in 1946, never converted to mass production, instead they used linoleum blocks until the mid-1950s, when they converted to hand-screen printing. Their retention of a hand-printing method allowed them to continue to explore the use of the same image on various cloths and their later panels (for which they are known) could either be laminated (as in the O'Hare Air-

A linen furnishing fabric hand linoleum-block printed by Eleanor and Henry Kluck (Elenhank Designers Inc), in 1946–47.

port counter facias of 1961) or adapted to fit any height — a factor they exploited increasingly in the late 1970s. Hand-printed fabrics and wallpapers, while relatively expensive, received such positive press coverage that they quickly ensured the presence of modern designs in mass-produced furnishings ranges.

Aside from the companies established in the 1930s, Britain, by contrast, had only one new firm rising out of the War to offer leadership in textile design. This was Heal's Wholesale and Export Ltd, formed in 1941 under the direction of Prudence

Maufe and Tom Worthington. Although it initially dealt with the export of a number of goods made from War surplus stock, the success of the textile ranges, begun in 1944, led to concentration on this product and a change of name to Heal Fabrics Ltd (HFL) in the following decade.

The new wholesale firm's reputation grew rapidly, based in part on the already established success of Heal's retail fabric department, which before the War had offered continental and British textiles, including some by Christopher Heal himself. Like those in other modern wallpaper and textile ranges in the immediate post-war years, HFL designs tended to remain small in order to restrict the repeat size (to minimize wastage). Colours were typically no more than four or five per design – another legacy from the War years. Even so there was no lack of variety. Many British manufacturers had run down their own design studios during the war and for some time afterward relied more often on freelance designers, a factor which rapidly restored their ranks to pre-war size. HFL itself purchased from over 75 different designers during its first 10 years of existence, most consistently relying on Jane Edgar, Dorothy Martin, Helen Close and, from 1950, Lucienne Day. To sell a design to HFL became a certification of success, and many who did so were

young designers, recently graduated from London's Central School of Art & Design or the post-graduate Royal College of Art.

Under the leadership of Dora Batty, the Central School had already established a reputation in the 1930s for its forward-looking furnishings designs. Batty's instruction placed emphasis on design for industry (at a time when the RCA was principally training teachers) and among her many successful students were Sylvia Priestly before the War and Mary Oliver and Audrey Tanner afterwards. The post-war drive to recapture export markets led to greater emphasis on training designers for industry and by the late 1940s the

Left, roller print on rayon by Roger Nicholson; right, screen-print on cotton by Marian Mahler. Both 1952, D. Whitehead Ltd.

RCA students were also entering into freelance design or starting their own firms.

Lucienne Day was among these RCA students, setting up in business in 1948 with her husband, the furniture designer Robin Day. She was to become the most prominent and enduring English pattern designer of the 1950s and 60s. Aside from her continuous supply of designs to firms such as HFL, Edinburgh Weavers and Cavendish Textiles (the brand-name of the department store John Lewis), there were wallpaper, carpet and table linen designs for German, American and Norwegian companies, the latter also including Rosenthal, for whom she designed porcelain from 1957–69.

For later London college graduates, there was still ample room to make their mark, for the British public's interest in modern design grew as the spending power increased during the late 1950s and 1960s.

Because HFL fabrics were mainly for export, hand-screen printed and expensive, they had limited circulation in the UK in the first years after the War. The first new British company to put its faith in the public's desire for *inexpensive* modern furnishing textiles after the War was David Whitehead Ltd, which appointed the architect John Murray in 1946. In the following year he transformed their range of inexpen-

sive, roller-printed fabrics by introducing designs which Murray described in *Design*, December 1950 as following, "*a fundamental tenet of the modern faith that the cheap need not be cheap-and-nasty.*" There were also inexpensive weaves, including some by Margaret Leichner who later became head of weaving at the RCA, but it was the prints which substantiated the wisdom of Whitehead's new policy. Both artists and designers provided patterns which supported the production of over a million pounds' worth of furnishing fabrics annually. The success of the modern roller prints (many by the painter Roger Nicholson, later Professor of Textiles at the RCA) led to the introduction of mechanized screen prints in 1958. It no doubt also contributed to HFL's confidence in the market for lower priced, modern textiles, as demonstrated in 1959 by the addition of roller prints, as well as mechanized screen prints, into their existing range of higher priced, hand-screen prints.

Meanwhile the smaller textile producers such as Sweden, Finland and Italy were consolidating their national styles. In Scandinavia the establishment of a welfare state during the 1950s linked modern design with a socially just society. The exception was Finland, which continued into the 1960s to view its mass-produced furnishings as entirely separate from the elitist,

expensive, hand-crafted pieces promoted by the 'star' designers such as the pieces – some with plastic films and wire – by the hand-weaver Majatta Metsovarra.

Italy, too, was moving rapidly towards a consciously luxurious interior style which supported such high-quality curtain and upholstery material as those printed or hand-woven by Fede Cheti or Reneta Bonfanti. Cheti, whose firm had been founded in 1930, also issued fabrics under her own name designed by artists including Giorgio de Chirico, Raoul Dufy and Gio Ponti. Among Italian freelance designers, the Vien-

'Ombria', a hand-screen printed chintz designed by Friedlande di Colbertaldo Dinzl in 1954 and produced by Warner's in England.

nese-born Comtessa Friedlande di Colbertaldo Dinzl established a reputation in the post-war years which ensured that her work was produced throughout Europe and particularly in England. Her fine-art based water-colour or collage images were among the first to exploit characteristics unique to screen printing.

The Italians were gradually able to supply many more of their own textiles and wallpapers, which had previosuly been imported from Germany and France. France itself ceased to be a major force in the origination of furnishings ideas, although many of its pre-war design studios remained active by producing a mixture of traditional and modern styles. By the 1950s, Germany was once again able to mass-produce furnishings, and firms such as Stuttgarten Gardinfabrik (textiles) and Rasch (wallpapers) led the mass market with their innovative designs.

Nevertheless, by the end of the 1950s European production of cheap, simple fabrics had been taken over by the near and far Eastern countries whose labour costs were still low. This affected Britain's manufacture of fabrics more than any other European country, and although wallpaper was not similarly affected, both increasingly became specialist products in which good design and technical excellence (rather than price) were the dominant features.

Furnishing fabrics by Althea McNish, 1959 and early 1960s for Liberty's.

initiated its architecturally scaled 'Palladio' range, but none of these were aimed at the mass market, where the prospects now seemed so poor.

Far from evolving a national style, individual company images developed and were supported by observers such as Dan Johnston, Industrial Officer of the CoID, who viewed the diversity of British furnishings as, "*a decisive factor for the success of British (export) trade.*" As Johnston recognized in *Design*, August 1957, "*in many cases the personality of the producer – the man who chooses the designs, organises their translation into cloth and finally*

supervises their sale – is more evident than the designers he employs." With Peter Simpson at Donald Brothers, Morton at Edinburgh Weavers (until his death in 1963), Hunter at Warner's until his death in 1958 and Straub at Warner's from 1950–70, such leading pre-war firms continued to provide their established blend of prints and weaves. Market forces tended to focus the new post-war firms into one area or the other, but whatever they sold, the styling of the designer-director was as obvious. One could recognize the hand of Eddie Pond at Wardle's in the early 1960s, Roger Nicholson's styling of the first six 'Palladio' ranges (which

Leadership towards this naturally came from the designer-led firms already established in the 1930s and 40s. New firms gradually joined them in the 1950s: Tibor Ltd, producing Jacquard weaves by Tibor Reich, and Conran Fabrics Ltd, with printed designs by Shirley and Terence Conran. Liberty's introduced its 'Young Liberty' range, among which Althea McNish's vivid, boldly drawn, influential designs were to be found. Crown (WPM), likewise,

A Pat Albeck design of the mid-60s, employing juxtaposed 'tile' and 'tribal' patterns in keeping with the '60s interest in ethnic artifacts.

started in 1956) and the impact of Harry Davy and Bill Brooke at Cavendish Textiles. But nowhere was strong individual styling more evident that in the screen-printed range of Hull Traders, where Shirley Craven commissioned and supplied designs from 1960 until the firms's closure in 1972. With Heal's, Hull Traders was to set the pace for British printed textile design in the 1960s.

The individual style put forward by the British manufacturers was supported by the many young freelance designers leaving college, to which the RCA and the Central contributed the core, including Conran, Pond, Craven, Davy, Brooke and McNish. The lack of a consensus on design dogma in these colleges was typified by the RCA,. where an absence of teaching was said to be the norm. The result was, to return to Johnston, that *"some designers (were) so surprisingly versatile that they (could) work successfully for producers whose ideas of good design differ greatly one from another."* He could well have been referring to those among the late 1950s RCA graduates who made such versatility their strength: Robert Dodd, Fay Hillier, Doreen Dyall and Pat Albeck.

In America, where the enormous internal markets supported both mass-produced and more expensive furnishings, philosophies of design education were more unified. A handful of institutions which 'Americanized' the Bauhaus principles were together responsible for spreading many of the new initiatives which characterized American national style in architecture and design in the 1950s and 1960s. For example, the location of so many new printing firms in the Chicago area – Ben Rose, Angelo Testa and Elenhank among them – was not coincidence since Chicago, from the late 1930s, had developed into an important centre of education. Serge Chermayeff took over at the Institute of Design after Moholy-Nagy's death in 1946 and, aside from also designing textiles and wallpapers, continued to attract celebrated teachers, mainly previously at the Bauhaus. The Armour Institute (where Mies van der Rohe taught architecture from 1938) was also in Chicago and these two institutes had merged with the Illinois Institute of Technology by 1949. There were also two further educational establishments which early on adopted the Bauhaus policies of visual training and a broadly-based foundation year: the Chicago School of Architecture and the Art Institute of Chicago. Elenor Kluck, who with her husband Hank Kluck formed Elenhank, had been a student at the latter.

The greater number of college-trained designers emerging from post-war courses which encouraged awareness of developments in other fields, naturally meant that surface design – especially for printed textiles and wallpapers – was closely aligned to developments in architecture and the fine arts in the two decades after the War.

In America and Scandinavia, the renewed interest in Functionalism during this period cast architecture in a leading role, bringing to furnishings in all price ranges a concentration on line, mass and colour. This can be seen in the 1940s and 1950s prints by the Danish architect Arne Jacobsen or Frank Lloyd Wright's wallpapers and fabrics for Schumacher in the 1950s. It was equally characterized in the work of many American, English and European designers. Architectonic, geometric designs were particularly prominent in Scandinavia, while the British use of so many designs by artists – Henry Moore, John Piper, Louis le Broquay and Graham Sutherland perhaps the best known among them – emphasized the idosyncratic nature of British furnishings design. More often than not this resulted in patterns which existed separately from the main-stream British developments in mass-produced furnishings and furniture, both of which employed organic, amorphous shapes. Many were influenced by scientific break-throughs of the period, although in borrowing atomic and microscopic imagery the

British were more literal than similarly influenced designers elsewhere, accounting for the failure of the 'Festical Pattern Group' crystallography designs produced for the Festival of Britain in 1951. The French followed a course similar to the British, with the wallpaper publishers, Noblis, typical in their use of painters, engravers, glass and furniture designers for their supply of patterns. Noblis designers included Suzanne Fontan, under whose name a sister-firm issuing fabrics was formed in 1953.

While woven fabrics of the 1950s moved steadily towards applications increasingly limited to corporate offices and public spaces and thus fell outside the 'fashion' sphere, prints and wallpapers continued to reflect the domestic market's need for changing styles. By the mid 1950s the 'vase and bowl', 'pits and pods' designs had a firm hold on these mass-produced goods. The most probable origin of the style was Ruth Adler Schnee, who set up her hand-screen printing workshop in 1947 and specialized in developing designs from everyday objects, many of which were shown in 'Design in Use, USA', her exhibition which toured Europe in c.1949–50. Such patterns suited the trend to democratize and de-mystify design and Adler's pedigree – Rhode Island School of Design and Cranbrook trained, and links with the Bauhaus – lent them credibility. Although now regarded as 'kitsch' and then regarded by many design critics as a fad, Adleresque patterns endured throughout the decade and can early be found in the ranges of Schiffer Prints (i.e. George Nelson designs), L. Anton Maix, Lee Jofa, Quintance and the other American firms who supported avant-garde furnishings design. They were designed in the Libert studio in Paris and by Willy Hermann in Berlin and produced in Britain by Warner's, Whitehead and others. By the mid-1950s they most typified mass-produced furnishings. Such still-life designs were particularly popular for kitchen and children's bedroom wallpaper and curtains and – in America – for dens, 'rumpus' rooms or other activity-related spaces. Whether the objects depicted on the fabric or paper matched those in the room seemed not to matter very much, except in Scandinavia.

There, by contrast, Elsa Gullberry's selection of work by herself and other Swedish artists, such as Vicke Lindstrand and Märta Afzelius, for mass-produced printed furnishing fabrics, presented a more consistent, unified image. Further, the contribution of wallpaper and textile designs from a broad spectrum of furniture and other product designers was common in post-war Scandinavia. A natural compatability thereby existed between the furnishings and pieces designed by inter-disciplinarians such as Alvar Aalto, Tyra Lundgren and Stig Lindberg (both ceramicists) and Bjorn Eng, a Norwegian designer best known for his copperware. This synthesis of interior styles is represented by the Scandinavian's early interest in well-designed table linen, which later extended to bed linen. Dora Jung, one of Finland's master weavers for almost half a century (1932–80) produced strong graphic patterns for production by Tampella linen works in Tampere, as did NK and the other major Scandinavian stores. Printed table linens were made popular in America and Europe by such initiative and rapidly replaced the traditional woven or embroidered tablecloths and napkins of the pre-war years. This move from weaves to prints was, of course, characteristic of furnishing fabrics as a whole, except in relation to modern furniture. Here the Scandinavian pre and post-war concepts of fabric specific to a certain piece of furniture remained influential, and had particular significance in America.

With good reason, the development of woven fabrics in this period has, to a large extent, been thus far passed over, for after the early 1950s the function and appearance of both hand and power-loomed goods developed on a different course. This course, as we have seen, was set in the

'The Stones of Bath', designed in 1962 by the artist John Piper, and screen-printed by Sanderson's.

1930s by the Europeans, but it was in America that the major post-war developments occurred. The combination of education and a handful of designer-led furniture manufacturers promoted a 'colour-and-weave' cloth devoid of almost any figurative elements. Such fabrics had been produced by hand in America before and during the War by weavers such as Dorothy Liebes, Willich-Franke Studios and, from 1938, Boris Kroll. They and post-war weavers such as Maria Kipp, Abbie J. Blum and Marie Nichols benefitted from economic factors which made hand-loomed fabrics competitive in price with power-loomed ones during the 1940s, and they also benefitted from the American acceptance and refinement of Bauhaus principles which, in general, led architects and furniture designers to select woven fabrics over prints.

The presence of European-trained weavers among American college staff was also significant in the sustained interest in woven fabrics. Albers at Black Mountain College in North Carolina from 1933–49 was only one of several weaver-teachers who had an influence through their own work as well as by training a generation of students who were themselves to become influential. Marli Erhman had also studied at the Bauhaus and from 1939–47 was head of the textile design workshop at the Chicago Institute of Design, after which she worked as textile consultant to H.S. Greenwald, who sponsored the Mies van der Rohe Building in Chicago, 1953. Ehrman, like other European weavers, believed that industrially produced fabrics should be developed on the hand loom. The *Everyday Art Quarterly* (1953) of the Walker Art Center records her description of designing for woven textiles, which could equally have been given by Straub or Leichner in England, Jung or Gullberry in Sweden, "*designing involves the construction of weaves, the choice of yarns, their colors and textures, with regard to their usefulness, feel and appeal of the finished material. But it also includes an analysis of the needs of contemporary living, of today's architecture, a survey of price values and the supplies of the textile market.*" These factors parallel Marianne Strengell's seven criteria for students planning weaving projects: materials, price, climate, labour, equipment, architectural placement and personalities.

Strengell's 25 years at Cranbrook Academy of Art were perhaps the most seminal for American woven fabrics in the post-war years. Cranbrook has often been associated with

'Fruit Cup', designed in 1952 in the Libert Studio, Paris, and typical of the 'vase and bowl' style of the first half of the 1950s.

the continued practice of Bauhaus principles, but the textile department was thoroughly Scandinavian. Swedish weavers, trained at Handarbetets in Stockholm or by Fjetterstrom in Bastad, had been imported in the years around 1930 to assist with the weaving necessary for furnishing the Academy, endowned by G.C. Booth and run by Eliel Saarinen. The weaving was carried out in Studio Loja Saarinen, named after Eliel's wife, who designed most of the early pieces. The first weaver to arrive late in 1929 was Maja Anderson Wirde, whose work was already well known through the influential Swedish Contemporary Decorative

Arts exhibition, shown in New York, Detroit and Chicago in 1927. A separate weaving department preceded the formal establishment of courses in 1932, which themselves were temporarily cancelled in 1933, the worst year of the depression for America.

In 1937 Strengell, a Finnish born weaver and student of Gullberry, joined the teaching staff at Cranbrook. She brought with her seven years' experience as a designer of highly-regarded, hand-woven rugs and furnishing fabrics for several Scandinvian firms, as recognized by inclusion of her work in the international exhibitions in Barcelona (1929), Antwerp (1932), Milan (1933) and Paris (1937). She was head of the weaving department by 1942, the same year in which the Academy was empowered to award higher degrees and the two-year post graduate programme began. Her commitment to design for mass production is evident in her introduction, in 1944, of a policy which allowed students to execute work for orders or sale; and, in 1945, of a powerloom – one of the first in an American art college (as opposed to a technical college). For the first year, teaching on the powerloom was the responsibility of Robert D. Sailors, an outstanding graduate of the Academy who later set up his own company and furthered his reputation for designing unusual yarns and

hand and power-woven fabrics. His samples included wefts of torn cotton strips, leather, Naugahyde and wooden sticks, the latter normally associated with Dorothy Liebes, who produced blinds of wooden slats and vividly-coloured mixed fibre warps.

Liebes was one of many established studios, firms and colleges who employed Cranbrook graduates — in Liebes' case it was Geraldine Funk Alvarez. The infrastructure of American leadership in post-war design and design education was thus based largely on the work of graduates of Cranbrook, together with the Chicago colleges, Black

Linen furnishing fabric, 'Pottery', by the Swedish ceramicist, Stig Lindberg. Printed by Ljungberg Textiltryck for NK in 1947.

Mountain College and a handful of other institutions, such as the Rhode Island School of Design.

From Cranbrook, Strengell herself excercised enormous influence through her work for industrial designers such as Raymond Loewy, Russell Wright and the Saarinen-Swanson Group and many companies in America, Finland, Germany, South America and Asia. Of her students two in particular — Ed Rossbach and Jack Lenor Larsen — ensured that Cranbrook had sustained representation in education and production. Rossbach had been a teacher before the War and after receiving his degree in 1947 returned to this profession, becoming one of America's most highly regarded design professors during his years on the faculty of the University of California, Berkeley.

Before taking up a position at Berkeley in 1950, Rossbach taught at the University of Washington, where one of his students was Larsen. The latter, by 1953, had completed his MFA at Cranbrook, formed and incorporated his own company and within ten years had branches in Zurich, Stuttgart and Paris. Larsen's meeting with Dorothy Liebes in 1947, his work in Los Angeles with the hand-weaver and teacher Dorothea Hulse (first as a student and later as a design assistant), his studies with Rossbach, Strengell and

Woven panel for Lincoln Continental by Marianne Strengell, 1959. Her interest in man-made fibres is reflected in her use of cotton, rayon and metal strip encased in polyester film.

particularly Sailors, culminated in what Christa Meyer Thurman describes in *Design in America: The Cranbrook Vision*, 1983 as a success which, *"would manifest itself in the ability to translate handwoven characteristics into mass-produced textiles."* This humanist quality distinguishes the Scandinavian/Cranbrook approach from the more hard-edged work of Bauhaus weavers such as Albers and Leichner.

While a handful of other weavers such as Marianne Straub had the same ability, Larsen's international recognition and leadership was exceptional, for most other weavers' work was anonymous by the time it reached the market place.

The anonymity of weavers occurred because the higher cost of good quality woven fabrics generally restricted their use to contract ranges or furniture makers. Straub designed the first fabric which sold 500,000 yards through HFL and from her studio in Ireland Gerd Hay-Edie (née Bergerson) produced cloth for Hille furniture throughout the late 1950s and 60s. Yet the public never knew. Even many of Strengell's cloths were eventually purchased without knowledge of the designer. Only Boris Kroll was able, like Larsen, to maintain mills and employ other designers. Their name, being the firm's name, ensured a measure of fame. For many other woven fabric designers it was a furniture maker whose name represented their work, and in America the most influential furniture/fabric firms in the post-war years were Knoll Associates and Herman Miller Inc. The latter was founded early in the 20th century and by the late 1930s had become a leader in the modern furniture industry. George Nelson, one of America's most articulate architect/industrial designers, became design director in

1946, working closely with Charles Eames and Alexander Girard, who established Miller's wallpaper and fabric division in 1953. The fabrics included upholstery cloths, casements and bright, bold prints. The wallpapers, like those designed in the 1930s by the French architect le Corbusier, had small patterns which from a distance, merged into one colour.

Knoll – until 1959 under the guidance of Florence Knoll, another Cranbrook graduate and an architect trained in London and at the Illinois Institute of Technology in Chicago – employed many more textile designers. Weaves were made available in c.1943, when Knoll joined the firm her husband had established in 1937 and prints followed a few years later. The firm introduced Scandinavian furniture into America and made famous the chairs by Mies van der Rohe and Marcel Breuer. Like the weaves and prints which Knoll promoted, such furniture represented the triumph of the International Style in corporate architecture and office furniture design, but was restricted to the residences of the design-conscious elite. Nevertheless the textiles they produced were if anything the more influential, being easier to copy. They too showed a debt to European design and its synthesis within American colleges. The Hungarian weaver, Eszter Haraszty, was director of textiles from 1949–55 and her assistant, the Swiss designer Suzanne Huguenin, took over from 1955–63. Fabrics by Evelyn Hill (an ex-student of Black Mountain College and the Institute of Design in Chicago), Testa, Stig Lindberg (best know for his work for Nordiska in Sweden), Sven Markelius, Sampe and Strengell typified the international nature of designs to be found in most ranges produced by leading American and European firms in the mid 1950s and 60s.

In *Design Since 1945* Jack Lenor Larsen described the post-war years as a period when, "*Design...was a cause, allied with the optimism of a world to be made over in the light of the Four Freedoms...the solution was so simple and clear... The new order would bring logic, coherence, beauty,*

From left: 'Lines' by Alexander Girard for Herman Miller Inc., 1952 (also produced as a wallpaper) and two HFL designs: 'Ducatoon', a roller print by Lucienne Day, 1959, and a screen print of c.1966 by Zhandra Rhodes.

'Melooni', a 1963 Marimekko design by Maija Isola, showing the bold scale for which the firm became known.

and meaning to all those subscribing to it. *Economics were hardly relevant.*" Economics had no need to be relevant: each year between 1945 and 1955 there were over 800,000 houses built in America alone. England and Europe were not far behind in beginning their rebuilding, and everywhere the uniformity of mass-housing programmes encouraged the use of bright, varied furnishings to create individuality or to divide rooms (whether large or small) into different use areas.

In Scandinavia this led to greater use of woven wall-hangings as already established in the 1930s, particularly in Sweden, where tapestry weavers benefitted from a 1937 policy requiring one per cent of budgets for public buildings to be allocated to artistic decoration. Very soon printed panels were being used in the same way. In the 1950s Astrid Sampe, for example, had NK print patterns by the painters Olle Baertling and Karl Axel Pehrson and the architect Sven Markelius, which were intended as 'pictures'. Panel-prints were also produced in limited numbers in England from the mid-1950s, although Warner's 1957 design by the artist Edward Bawden was typical of most in that it sold far better on the continent than in England. In America this fashion was echoed in the popularity of 'mural' wallpapers, in the supply of which firms such as Van Luit & Co. and Murals Inc. of New York specialized. It was not until the early 1960s that flat printed textiles designed *as* textiles *by* textile designers began to be hung as flat panels or used for roller blinds. The ease of handling large screens in conjunction with machine printing was crucial in the introduction of these large scale prints into the western world's mass market. The stylistic lead was provided by the Finnish firm Marimekko (founded by Armi Ratia in 1951) with their bold, vivid prints of the early 1960s by Ratia, Maija Isola, Marjatta Metsovarra, Liisa Suvanto and Vuokko Eskolin.

The acceptance of textiles and wallpapers as design-worthy objects in their own right reached its peak in the 1960s as a result of economic, social and political forces which focussed attention on the education of designers, the education of the public and the compatability of Good Design with profit-making. The gap between expensive, exclusive, innovative designs and mass-produced furnishings was much less noticeable. The democratic spirit made the former more accessible, the booming economy made designing for the latter more respectable and the mechanization of screen printing made it possible. For designers, whether freelance or in-house, it was a period during which exhibitions, magazines and design organizations ensured that much credit was given where it was due. Design was a vocation. Ahead, for a few, lay empires. The way in which they built them — and the way in which changes in retailing, exhibitions and publications directed both consumers and manufacturers towards a new approach to design — underlies the major characteristics of the post-1965 period.

THE GREAT ESCAPE

- DESIGN: 1964 - TODAY

AS the various media and media events – whether television, advertisements, magazines, books or exhibitions – increased after the end of World War II, so too did the power of imagery. Logos, signatures, initials and other motifs which could be 'read' quickly thus became the most effective tools of communication. The objective was primarily to associate every individual item or unit with the larger network to which it belonged. Corporate identity programmes stressed single ownership of different types of companies; 'designer' labels focussed on the stylist rather than the manufacturer; thematic presentation became more important and with it co-ordination. A firm's style became just as much a concern of furnishings manufacturers as fine artists. The emphasis on style can be said to characterize the whole of the last two decades irrespective of the pluralistic approach which has been taken towards design during this period.

While many of the trends towards the 'corporatization' of style were present prior to 1965, it was in this year that, as Eddie Pond recalled in

'Dormire', a roller-printed cotton furnishing fabric designed by Giorgio de Ferrasi and produced by Colli 2 in Italy, 1974.

Did Britain Make It?, 1986:

"suddenly it all happened. The Rolling Stones, The Supremes, Percy Sledge, Edwin Starr, The Chiffons, Little Stevie Wonder, mini-skirts, Art Nouveau, Art Deco, Voysey, William Morris, Bridget Reilly, Brigitte Bardot, Batman and Robin, James Bond, Habitat, King's Road, carrier bags, paper dresses, paper knickers, cardboard furniture, Polypops, Paperchase, Aretusa, Mr Freedom, Mr Feed'um, Bus Stop Biba, Clobber, Ossie Clark, Mary Quant, and 'Puppet on a String' till you wanted to scream."

This explosion of youth oriented consumer goods and boutiques marked a change in mass-market style and selling techniques. The disenchantment of the post-war generation responsible for the 'Swinging Sixties' was diametrically opposed to the reforming zeal of the intellectually and technologically biased generation which preceded it. Inspirations were drawn instead from fashion, films and music, from

the fine arts and travel, all of which offered an escape from the disillusion which grew stronger as the 1960s progressed.

In *High Styles,* 1985, Martin Filler observed of the emerging feeling in America:

"that the possibilities for new expression within the modernist mode had been more or less exhausted, and that a new direction was required to convey the very different values that had begun to prevail in American society. As early as 1964, Norman Mailer could write convincingly of 'some process of derailment' in this country, which for him seemed triggered by the deaths of Ernest Hemmingway and Marilyn Munroe, and culminated for the country at large with President Kennedy's assassination. Soon thereafter the United States undertook the first major escalation of the war in Vietnam, initiating a spasm of violence and upheaval unknown in America since the Civil War. That sense of displacement, of a center that no longer held, was swiftly picked up by innovation designers."

Similar undercurrents of discontent manifested themselves in the UK and Europe, giving rise — more or less simultaneously everywhere — to various forms of 'Pop Design'.

In its satirical manipulation and

The interest in designs built up from dots is reflected in this 1968 screen printed fabric ('Isometric') by Sue Palmer at Warner's.

distortion of familiar objects, Pop design furnishings such as Andy Warhol's 'Cows' wallpaper are easily recognized. Other elements of Pop art were also shared with furnishings: the recycling of objects originally for a different purpose and the cynical adoption of imagery from advertisements were both reflected in the use of billboard papers as wallcoverings. Well into the first years of the 1970s the enlarged dots and broad outlines of Roy Lichtenstein's 'comics' could be found on both textiles and wallpapers. The bright, scaled-up Art

Nouveau and Art Deco patterns were quotations in the same vein. Even the large, flat, stylized flowers, such as the five-petal variety which became associated with Mary Quant, can be read as parodies of the traditional floral chintz. It was this type of pattern, rather than the pure visual trickery of Op art-inspired designs, which pervaded the mass market.

The alliance between Pop art and Pop furnishings was strengthened by the parallels which existed between their fundamental tenets. The American artist Richard Hamilton outlined

these in 1957, as based on the popular, transient, expendible, low-cost, mass-produced output of big businesses with the additional emphasis on the young, witty and glamorous. This led to artists' involvement in techniques such as silk-screening and photography, which eased the transference of Pop images to wallpapers and textiles. This cross-fertilization occurred almost a decade after the introduction of Pop art and its effect was to soften what had at first shocked.

Although Pop design was seemingly opposed to the 'big-is-beautiful' corporations, the world of high fashion or anything, in fact, that suggested the 'Establishment', the urge to humanize was common to both. Burlington's massive advertising campaign of the late 1960s sought to de-mystify their diverse and widespread operations. The desire to inject personality into the mass-produced furnishings of the large conglomerates was first apparent in their introduction of designer sheets. Everett Brown's pioneering mid 1960s collections for Fieldcrest were unacknowledged; but Spring Mill's Emilio Pucci group sold well and further proliferated the status symbol signature of the Italian designer. By the second half of the 1960s 'Vera' became a household name in America, appearing on countless printed sheets, kitchen towels and table linens. All were created by Vera Neumann, a Weiner Werkstätte-trained designer who, with her husband, George, began printing wallpapers and textiles in the 1940s subsequently establishing Printex Corporation of America.

As barriers broke down under the pressure of Pop art and design, the gulf between fashion and furnishings also narrowed, and the pressure to diversify in the early 1970s contributed to fashion designers' interest in a wide range of products. Thereafter it was primarily a fashion designer's name — Dior, Calvin Klein, Bill Blass, Mary Quant — which acted as the vehicle for publicizing and personalizing the household textile ranges of the large conglomerates.

The sustained growth of polyester/cotton sheeting manufacture throughout the last 20 years was supported by increased use of central heating and duvets. It was, however, made possible in the first place a landmark improvement to rotary (roller) screen printing, introduced by Stork, a textile engineering firm in Amsterdam. Although rotary printing had been available from c.1954, when flat-bed printing was also initiated, the coarse wire-mesh screen for the former was made flat and welded into a cylinder. This precluded the use of continuous fine lines and required careful design-planning to disguise screen joins. Stork's perfection of a seamless nickel cylinder, engraved photographically by means of electro-decomposition, eliminated these faults. Subsequent improvements to the shape of the perforations allowed even finer detail: today 90 per cent of all fabrics world-wide are rotary printed. The Stork machine, available from c.1963, not only made printed sheets economically and aesthetically viable, it also promoted the now universal use on polyester/cotton of pigment dyes, which had been developed out of German war-related research, initially directed towards the isolation of a synthetic rubber compound.

Other technological breakthroughs were adopted by the furnishings industry. From the American space program came Mylar, which in the early 1970s was adapted for use as a printing base for wallpapers. The imagery of the space-age was also co-opted by designers. In France, Jean Vigne actually printed a photograph of the moon's surface on Mylar in 1978; other French firms, such as Foucray, had earlier produced wallpapers with a 'collage' of various space ships and scenes. In England at Warner's, Eddie Squires and Sue Palmer produced textile designs to commemorate man's landing on the moon in 1969, and in America such images became a permanent part of the visual vocabulary of design for

children's bed linen, which was the only large market for which the patterns proved useful. Otherwise such designs fit well within the transient, expendible idiom of Pop. Under the optimistic surface of these and other Pop inspired, vividly-coloured designs of the late 60s and early 70s lay an urgent sense of unease which quickly became apparent in the return to a more naturalistic style.

Naturalism in furnishings manifested itself in a variety of different

'Comic Strip' roller-printed furnishing fabric produced by Fieldcrest, 1970. (The images were reproduced from three comic-strip stories in the Chicago Tribune.*)*

ways: in a return to natural fibres, in the re-emergence of the popularity of traditional styles, and in the crafts revival. Natural fibres were restored to favour by a series of events which were brought into focus by the oil crisis of 1972/3. The concern for ecological issues, the cutbacks in synthetics manufacture, increased travel – especially to India, and the 'alternative' lifestyle of the young contributed to the reassessment of the appearance, handle and behavioural characteristics of handspun and naturally dyed fibres. The effects were the most striking in fashion (which had adopted synthetics on a larger scale), as evidenced by the acceptance, and later the imitation of fading, wrinkles and irregular yarns. As colour trends moved from 'brights' to pastels in the mid-1970s, the chemical dyes re-created shades associated with the faded tones of natural dyes such as madder, indigo and weld, resulting in the peach/pinks, pale blues and warm yellows which dominated furnishings of the period.

In high-quality woven fabrics natural fibres had never lost their prominence. From the mid 1960s the weaves of Knoll, Larsen and Kroll in America, Tamesa (Straub designs), Donald Brothers and Margo Textiles International in England and European firms such as C. Oleson and Spindegarden in Denmark, Bonfanti

in Italy, Rohi Stoffe GmbH in West Germany, and Metsovarra van Harer in Finland provided the impetus for many of the fibre and dye techniques which were imitated in furnishings in all price ranges.

The Pop tendency to transfer images of one product to another found its most lasting application in the imitation of textures and weaves, of which the printed Middle Eastern carpet patterns of the early 1970s are one example. Advances in photogravure wallpaper printing, which contributed naturalistic brick wall patterns to the repertoire of wallcoverings, also made possible papers resembling linen, silk, hessian or textured cottons such as those produced in England in Shand Kydd's 1964–5 'Focus' range. Like other companies in Europe and America, the Noblis, Fardis and Follot companies in France began importing grasscloth wall-coverings from Korea and Japan. These were later issued with the addition of printed images underneath the vertically placed strands of grass. The Noblis success with this type of wall-covering is such that in 1982 they are recorded (in *Wallpaper: A History*) as selling 800 rolls a day.

Texture appeared in synthetic yarns and, in printed textiles and wallpapers, became a dominant feature of modern designs — whether the literal use or weave structures or the effect of stippling, hatching, or

uneven lines and tones. The longevity of the naturalistic trend was recognized by Sheila Hicks (in *Textiles for the Eighties*, 1985) as significant, for while,

"we are benefitting from the intertwining of natural and man-made fibres... It is no longer sensible to ignore and recoil from the technological miracles on the horizon. (Yet) we are swayed by the rhetoric which reassures us that nature-generated materials are superior. And with them, we are psychologically comforted in what continues to be this 'age of anxiety'."

A display of Colorall Ltd wallpapers in the Design Council's London conference room, 1970. Culturally anonymous designs such as these were produced widely.

The crafts revival, of which the return to texture and natural fibres was an integral part, both preceded and outlived Pop design. Within the revival were also signs of a reaction against internationalism, so that by the 1970s the American interest in patchwork and appliqué was evident in the textile and wallpaper ranges of firms such as Greeff. In Britain — where crafts were inextricably linked to the Arts and Crafts – the re-printing of William Morris patterns began again in earnest in the mid-1950s. Today Liberty's, John Lewis's and Sandersons still offer machine-printed versions of Morris patterns, the latter also providing both hand and machine-printed papers. The nation-specific reference contained within such designs has also confined their production and distribution largely to the country of origin. Although a handful of Morris patterns are available in the US through Scalamandré Inc., America has never consumed these designs in the quantity that has allowed even interpretations of Morris patterning techniques (such as Pat Albeck's 'Daisy Chain' for John Lewis) continuous production in the UK for 20 years. The American bi-centennial of 1976 gave a temporary boost to the wider use of patchwork-type designs, but these too only retained currency in their domestic market thereafter.

On the occasion of the Textile Institute's 75th anniversary in 1985, Dr. Otto Thur, Chairman of the Textile and Clothing Board of Canada was thus able to recognize within the wide variety of ethnic or provincial patterns produced in the last 20 years, a trend towards, *"creative self-expression influenced by national, regional or individual cultural backgrounds (which) is the dominant featuretoday. Long gone are the days when beauty and 'progress' in pure or applied arts were disseminated as a canon by any specific predominating centre of creation."* As a result, the only craft revival styles

which found widespread use were those that were culturally anonymous: trelliswork patterns based on basketry, small patterns from hand-printed 18th and early 19th-century cottons, and the stencils, stripes, textures and checks of universal origins. The very anonymity of such patterns quickly eliminated the association of designer names with them, and, instead, it was international firms such as Habitat and Laura Ashley, for example, which came to epitomize English 'rural' interiors (both modern and traditional) for the middle-class urban dweller.

From the early 1970s there were fewer new houses built as a result of the recession thereby raising the premium of older houses and increasing interest in restoration. Decorators and furnishings manufacturers specializing in 'document' styles flourished, as did interest in museum collections, company archives and rehabilitated mills and factories. Such interests were also supported by wider issues, such as ecological preservation and the re-assessment of the historical contribution of minority groups to cultural, political and industrial developments. As with Pop designs, these retrospective trends symbolized the search for security. By the late 1970s, the key words in furnishings were 'country', 'cosy' and 'chintz', for, to use a phase from

Heal's press release of 1977, *"the mood nowadays is for softer more romantic designs in fabrics to match the current feeling for reassurance which is given by the home."*

Proof that the countrified style – whether 'peasant' or 'gentry' – was only skin deep is that corporatization and diversification continued to be the essential elements for survival. For example, despite the recession, the giant corporations of America, France, Germany and Britain still rank among the world's largest firms. Their continued expansion is typified by the recent purchase of Sanderson's by the American conglomerate, Westpoint-Pepperell.

Diversification has created some unlikely associations: Knoll was taken over by Art Metal in 1968 and in 1977 was sold to General Felt and Warners and Greeff have recently been sold to Wickes, a now international firm which began as a small lumber merchant. But for the smaller firms, particularly those with well-identified styles, diversification has principally occurred through the extension to related products.

Larsen, as already noted, had grown to international size by 1963 and since then run workshops in Haiti, Vietnam and Africa, as well as acquiring Thaibok Fabrics Ltd in 1972 and establishing carpet, leather and furniture diversions. Habitat, founded by Terence Conran in 1964,

is also now international, and the Conran 'style', described in *The Conran Directory of Design*, 1985 as *"sophisticated, professional retailing"*, can now be seen in a wide range of retail concerns, including Heal's, which was purchased in 1983. In France, Noblis added fabrics and imported wallpapers to its own wallpaper range in 1976, while the fabric firms of Manuel Canovas and Pierre Frey did the reverse, beginning wallpaper publishing in 1965 and 1977 respectively.

Such diversification has occurred at all price-levels. In England, for example, Coloroll began as a paper bag manufacturer in the 1960s, progressing through greeting cards and wallpapers to their present domination of low-cost retail wallcoverings and textiles. In the middle price range, Laura Ashley is best known, and their international success is based on their extension from fashion into a co-ordinated range of furnishing fabrics, wallpapers, paints and interior accessories which was completed by 1975. For those with a little more money to spend, Osborne & Little, founded by Peter Osborne and Antony Little in 1968, offered wallpapers of their own manufacture and design, to which were added fabrics in the 1970s and, in 1986, a range of bed-linen, carpets, tiles, trimmings and furniture – all this in addition to their acquisition of Tamesa Fabric

A design from the Heal's 1980 collection – 'Fantasia' by Hayden Williams, demonstrating the use of jagged lines or cross-hatching as a means of adding 'texture' to screen-prints .

in 1985. Tamesa itself was the by-product of a takeover, for it had been established in 1964 by Isabel Tisdall, stylist at Edinburgh Weavers until the latter was purchased by Courtauld's.

With co-ordination as the emphasis of these British firms, the importance of the house style outweighed the advantages of promoting individual designers, who were thus further removed from the public eye. Since wherever co-ordination dominates this is the case, the designer diminished in importance in the four major western countries –

the UK, USA, Germany and France – where market focusing was used in the search for 'best-sellers', where styling and co-ordination were paramount, in other words, where corporatization and diversification were strongest.

The designers who came to prominence in the last 20 years were those who owned their own firms. Susan Collier was relatively unknown while designing for Liberty's, and it was not until 1979, when she established Collier Campbell with her sister Sarah, that their painterly style received recognition.

Some firms such as Francis Butler's Goodstuffs Inc., operating in California during the late 1960s and 70s, had short-lived but influential lives. Others were more lasting. For example, in Stockholm, the Group of Ten was established in 1970 by ten (now six) designers who joined together specifically to control the design, manufacture and sale of their textiles and wallpapers. Today their bright, casual designs, intended to be lasting rather than 'modern', are internationally known.

There are, of course, many isolated examples of larger firms who promote innovation or the designers who work for them, among which are Warner's in England, JAB and Intair in West Germany, Mira-X in Switzerland and Marieta in Spain. But where the large conglomerates dominate production, the designer's access to the public is generally much more restricted. It is therefore no surprise that in America and the UK, where the scale of corporatization in the early 1980s was represented by a concentration of over 60 per cent of furnishings employment in the top ten firms (by size), there emerged an associated concern for the future of the young designers leaving college.

Areas traditionally or geographically outside the sphere of the conglomerates remained more flexible. While individual instances of design innovation could be found every-

Above: Robert Venturi's 'Grandmother Roses', 1984. The same pattern was applied to Venturi-designed chairs, also manufactured by Knoll.

Top left: Howard Hodgkin's room in the British Arts Council's 'Four Rooms' exhibition, 1984.

Left: 'Bright Havanna' and 'Cote d'Azur' from Collier Campbell's '6 views' collection which won the Design Council's Duke of Edinburgh Award in 1984.

Warner's policy of promoting 'named' designers is reflected in their 1984 'Designer's Choice' collection and their 1986 'Four Styles' collection (top right only). Clockwise from top left they are by Eddie Squires, Alex Fenner, Ann White and Sue Palmer.

where in the early 1980s, it was in Italy and Japan (and to a lesser extent Scandinavia and Germany), that new ideas reached the market place most readily. Japanese designers such as Hiroshi Awatsuji, Fujiwo Ishimoto, Masakazu Kobayshi and Katsuji Wakisaka have proven to be particularly influential during the last ten years, both in their own country and abroad. Wakisaka designed printed textiles for two firms in Japan – Itoh and Samejema – before spending 1968 to 1976 with Marimekko in Finland and subsequent years designing both printed and woven textiles for Larsen in New York and Wacoal in Tokyo. After designing for Ichida for six years, Ishimoto, too, left Japan and since 1974 has been at Marimekko. Knoll, after years of supporting European design, now have the Japanese designer Utsumi at the head of their textile studio. In Italy, where the design and manufacture of furniture, garments and textiles has remained dispersed, the influences of anti-fashion have been strongest, particularly those arising from the trends set by Ettore Sottsass at Memphis and Elio Fiorucci at Fiorucci. Receptivity to Italian style in America is further demonstrated by the fact that in 1980 Herman Miller employed the Italian colour theorist and designer Clino Castelli to develop a co-ordinated colour, fabric, finish and texture system for their 'Action Office'

furniture line.

While the UK remains a stronghold of manufacture for wallpapers, both Italy and Japan are among the few major net exporters of textiles, thus ensuring that their style has world-wide impact. India, too, with its improved quality control, has influenced the appearance of both textiles and wallpapers in Europe and America with its continually increasing provision of cotton ikats and simply woven silks.

The European and American contribution to the furnishings industry has not, of course, ceased, but its primary focus in recent years has been in style-marketing and technological developments such as computer-controlled patterning and laser engraving. However, the revolution in 'life-style' and 'self-awareness' continues, and is today led by the American and European Post-Modernist architects, whose mannered approach embraces period style and the desire to escape into the past. Robert Venturi and Michael Graves are only two of these leading architects who have also begun to design wallpapers and textiles together with other items for the home, and such designs are beginning to influence the mass-market. The result is a continuation of the trends begun in the mid-1960s.

Although the appearance of wall-

papers and textiles has varied throughout the century, the vehicles by which they were promoted have remained the same. The rôle of the style-lobbyist has nevertheless become more institutionalized as the century progressed. No clearer evidence of this can be found than in Lisa Phillip's comments in *High Styles*, 1985, which, while referring to America, pertain equally to Europe today:

"Style suggests at once intelligence, talent, originality, glamour, and power. As one of the most visible signs of success in our culture, style is relentlessly, even obsessively pursued. An entire industry has arisen to offer advice, models, and products for the attainment of style. Certain magazines are exclusively devoted to transmitting its secrets – New York, Interview, Vogue, Vanity Fair – and they advertise products that promise to assist in the magical before-and-after transformation. Even the conservative money magazines take note: Forbes recently reported that the uniqueness of the Yuppie consumption pattern turns out to be 'about style, not volume', and concluded that the baby boom generation selects 'style over substance'. Today, style has invaded every aspect of our lives; it is the symptom and condition of our hyper-real, hyper-consumer world."

As a result of awareness of 'style', advertising of furnishings has become increasingly sophisticated, as demonstrated by this 1985 Osborne & Little advertisement for the 'Regatta' collection.

The economic importance of textiles and wallpaper production and their key role as indicators of cultural values and achievements has ensured that this search for style has been enshrined in their design, manufacture and presentation.

BIBLIOGRAPHY

* = those books which should be consulted for bibliographies useful in the study of more specific topics.

*BATTERSBY, M. *The Decorative Twenties* Studio Vista, London, 1969.

BAYLEY, S. (ed) *The Conran Directory of Design 1985* Conran Octopus Ltd, London, 1985.

BILLCLIFFE, R. *Mackintosh Textile Designs* John Murray Ltd, London, 1982.

BROWN, E. *Sixty years of Interior Design: The World of McMillan* Viking Press, New York, 1982.

CABLE, V. *World Textile Trade and Production: EIU Special Report No.63* The Economist Intelligence Unit Ltd, London, 1979.

CAPLAN, R. *By Design* McGraw-Hill Book Co., New York, 1982.

*COATTS, M. *A Weaver's Life: Ethel Mairet 1872–1952* Crafts Council, London, 1983.

*COLEMAN, D.C. *Courtaulds: An Economic and Social History: Vol II* O.U.P., London, 1969.

*COLLINS, J. *The Omega Workshops* Secker & Warburg, London, 1984.

CORNFORTH, J. & FOWLER, J. *English Decoration in the 18th Century* Barrie & Jenkins Ltd, London, 1978.

CRAWFORD, M.D.C. *The Heritage of Cotton: The Fibre of Two Worlds and Many Ages* Fairchild Publishing Co., New York, 1948.

DE OSMA, G. *Mariano Fortuny: His Life and Work* Aurum Press Ltd, London, 1980.

DE WOLFE, E. *The House in Good Taste* Century Co., New York, 1915.

*DAVIES, K. *At Home in Manhatten: Modern Decorative Arts, 1925 to the Depression* Yale University Art Gallery, New Haven, 1983.

DENYER, R. & SONDHEIM, W. (eds) *75th Anniversary Souvenir Publication 1985* The Textile Institute, Manchester, 1985.

DETROIT INSTITUTE OF ARTS *Arts and Crafts in Detroit 1906–1976: The Movement, the Society, the School* 1976.

DETROIT INSTITUTE OF ARTS & METROPOLITAN MUSEUM OF ART *Design in America: The Cranbrook Vision* Harry N. Abrams, New York, 1983.

*DUNCAN, A. *Art Deco Furniture: The French Designers* Thames & Hudson, London, 1984.

DUNWELL, S. *The Run of the Mill* David R. Godine, Massachusetts, 1978.

FRANKL, P. *New Dimensions* Payson & Clarke, New York, 1928.

*GOMBRICH, E.H.J. *The Sense of Order: a Study in the Psychology of Decorative Arts* Cornell University Press, New York, 1978.

GOODDEN, S. *A History of Heal's* Heal & Son Ltd, London, 1984.

*GREYSMITH, B. *Wallpaper* Macmillan, New York, 1976.

GUENEAU, L. *Lyon et le Commerce de la Soie* Faculté de Droit de l'Université de Lyon, 1923.

HAYES MARSHALL, H.G. *British Textile Designers Today* F. Lewis Ltd, Lea-on-Sea, 1939.

*HAMILTON, J. *An Introduction to Wallpaper* HMSO, London, 1981.

HENNESSEY, W.J. *Modern Furnishings for the Home* Reinhold Publishing Corporation, New York, 1952

(Vol I) and 1956 (Vol II).

HOOPER, L. *Hand Loom Weaving* John Hogg, London, 1910.

*LACKSCHWITZ, G. *Interior Design and Decoration: A Bibliography* New York Public Library, New York, 1961.

LEWIS, F. (ed) *British Designers and Their Work* F. Lewis Ltd, Leigh-on-Sea, 1941.

*LYNN, C. *Wallpapers in America from the Seventeenth Century to World War I* W.W. Norton & Co., Inc., New York, 1980.

*MacCARTHY, F. *All Things Bright and Beautiful* University of Toronto Press, Toronto and Buffalo, 1972.

*MacCARTHY, F. *British Design Since 1880* Lund Humphries Publishers Ltd, London, 1982.

McALHONE, B. (ed) *Directors on Design: The Textile Industry* The Design Council, London, 1985.

*McCELLAND, N.V. *Historic Wall-Papers from their Inception to the Introduction of Machinery* J.B. Lippincott Co., Philadelphia, 1924.

MARTIN, E. & SYDHOFF, B. *Swedish Textile Art* Liberförlag, Stockholm, 1980.

MENDES, V. & PARRY, L. *British Textile Design in the Victoria & Albert Museum, Vol III* Gakken Co. Ltd, Tokyo, 1980.

MORTON, J. *Three Generations in a Family Textile Firm* Routledge &

Kegan Paul, London, 1971.

OLSEN, R.P. *The Textile Industry* Lexington Books, Massachusetts, 1977.

*PARRY, L. *William Morris Textiles* George Weidenfeld & Nicolson Ltd, London, 1983.

PEVSNER, N. *An Enquiry into Industrial Art in England* C.U.P., Cambridge, 1937.

POOL, M.J. & SEEBOHM, C. (eds) *20th Century Decorating, Architecture & Gardens .. from 'House & Gardens'* Weidenfeld & Nicolson, London, 1980.

*PRATHER-MOSES, A.I. *The International Dictionary of Women Workers in the Decorative Arts* Scarecrow Press, New Jersey, 1981.

QUIMBY, I.M.B. (ed) *Material Culture and the Study of American Life* W.W. Norton, New York, 1978.

RODIER, P. *The Romance of French Weaving* Tudor Publishing Co., New York, 1936.

*SCHOESER, M. *Marianne Straub* The Design Council, London, 1984.

*SCHWEIGER, W.J. *Wiener Werkstatte – Design in Vienna 1903–1932* Thames & Hudson, London, 1984.

SEALE, W. *The Tasteful Interlude: American Interiors Through the Camera's Eye, 1860–1917* Praeger, New York, 2nd ed., 1981.

SHEPHERD, G. *Textile-industry Adjustment in Developed Countries* Trade Policy Research Centre, London, 1981.

*SIMPSON, W.H. *Some Aspects of America's Textile Industry* University of South Carolina, Colombia, 1966.

SOCIETY OF INDUSTRIAL ARTISTS AND DESIGNERS *Designers in Britain 3: 1851–1951* Allan Wingate, London, 1951.

SPARKE, P. *Furniture* Bell & Hyman, London, 1986.

SPARKE, P. (ed) *Did Britain Make It?* The Design Council, London, 1986.

*TEYNAC, F., NOBT, P. & VIVIEN, J. *Wallpaper: A History* Thames & Hudson, London, 1982.

*TURNBULL, G. *A History of the Calico Printing Industry of Great Britain* John Sherratt & Son, Altringham, 1951.

WPM 1899–1949: The Pattern of a Great Organisation The Wallpaper Manufacturers Ltd, Manchester, 1949.

WELLS, F.A. *Hollins and Viyella* Latimer Trend & Co. Ltd, Plymouth, and A.M. Kelly, New York, 1968.

WILSON, R. *Paris on Parade* Bobbs-Merrill, Indianapolis, 1925.

*WOODHAM, J.M. *Industrial Design and the Public* Pembridge Press, London, 1983.

YASINSKAYA, I. *Soviet Textile*

Design of the Revolutionary Period Thames & Hudson, London, 1983.

Exhibition Catalogues
ALEXANDER GIRARD DESIGNS: *Fabric and Furniture* Goldstein Gallery, University of Minnisota, 1985.
BURY, H. *A Choice of Design, 1850–1980; Fabrics by Warner & Sons Ltd* Warner & Sons Ltd, London, 1981.
*HIESINGER, K.B. & MARCUS, G.H. (eds) *Design Since 1945* Philadelphia Museum of Art, 1983.
LARSEN, J.L. *Jack Lenor Larsen: 30 Years of Creative Textiles* Jack Lenor Larsen Inc., New York, 1981.
MIDDLESEX POLYTECHNIC *A London Design Studio 1880–1963: The Silver Studio Collection* Lund Humphries, London, 1980.
MUSEUM OF MODERN ART *Textiles USA* New York, 1956.
PHILLIPS, L. (ed) *High Styles: Twentieth Century American Design* Whitney Museum of American Art, New York, 1985.
*ROBERTSON, B. & UNDERWOOD, J. (eds) *Raoul Dufy* Arts Council of Great Britain, London, 1983.
SCHOESER, M. *Fifties' Printed Textiles* Warner & Sons Ltd, London, 1985.
TULOKAS, M. (ed) *Textiles for the Eighties* Rhode Island School of Design, Providence, 1985.
USHERWOOD, N. *Joyce Clissold* Brentford Watermans Arts Centre, 1984.
*VICTORIA & ALBERT MUSEUM *Designs for British Dress and Furnishing Fabrics: 18th Century to the Present* Victoria & Albert Museum, London, 1986.
VICTORIA & ALBERT MUSEUM *From East to West: Textiles from G.P. & J. Baker* G.P. & J. Baker, London, 1984.
WOODS, C. *Sanderson's 1860–1985* Arthur Sanderson & Sons Ltd, London, 1985.

ACKNOWLEDGEMENTS

The information presented in the preceding chapters would not have been possible without access to research undertaken by others. I would particularly like to thank Dilys Blum for information on M. D. C. Crawford, Dave Cohen for the copy of his unpublished MA thesis on Cheney Brothers and access to his private collection of Cheney fabrics, Hester Bury for information on Greeff Fabrics Inc, and Amelia Peck, Christa Meyer-Thurman, Gillian Moss, Althea McNish, L. St. J. Tibbitts, John Wight, Dr. Gordon Rintoul, Donald Tomlinson, Marianne Straub, Charles Williams, Pat Albeck, Michael Regen and Eddie Squires for their suggestions, advice and information. Christine Boydell and Andrew Clay criticized the book while in manuscript stage, and I am indebted to them for this immeasurable assistance. My thanks are also offered to all those who were involoved in the production of this book, particularly Emma Jones of Bell & Hyman, who undertook both the picture research and the editing. Finally, mention must be made of my mother, Margaret Schoeser, who, on this and numerous other occasions, has undertaken the thankless tasks of proof-reader, coffee-maker and sounding board.

INDEX

Numbers in bold indicate an illustration